LEGO Still Life with Bricks

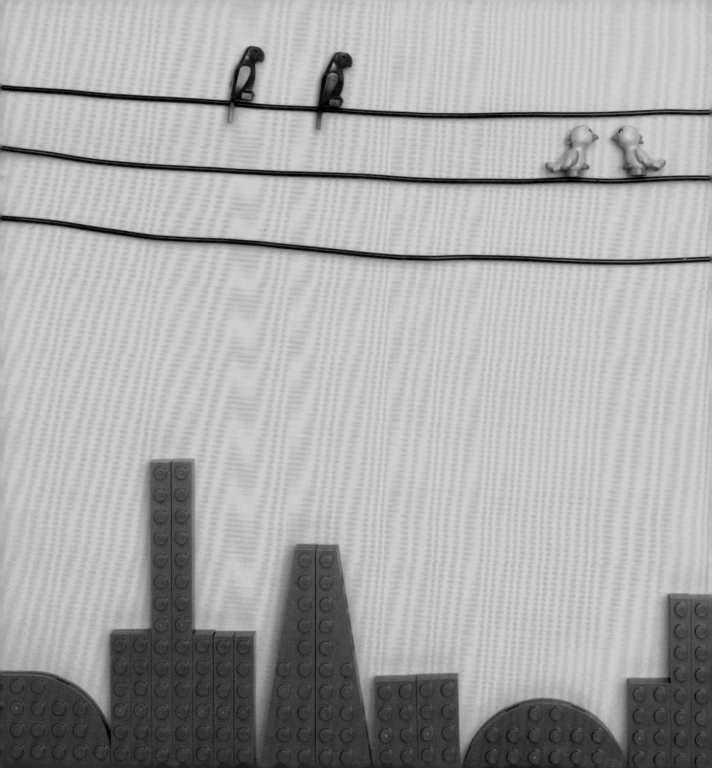

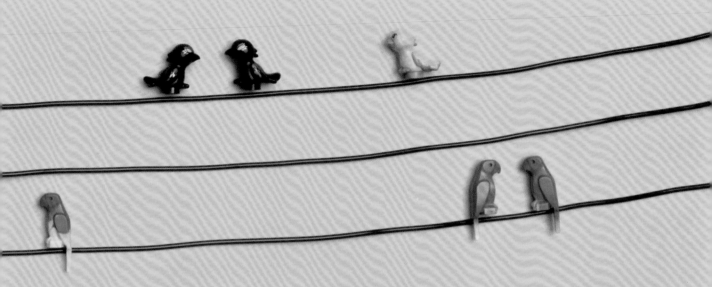

 Still Life with Bricks

The Art of Everyday Play

by Michelle Clair and Lydia Ortiz

Photographs by Patrick Rafanan

CHRONICLE BOOKS
SAN FRANCISCO

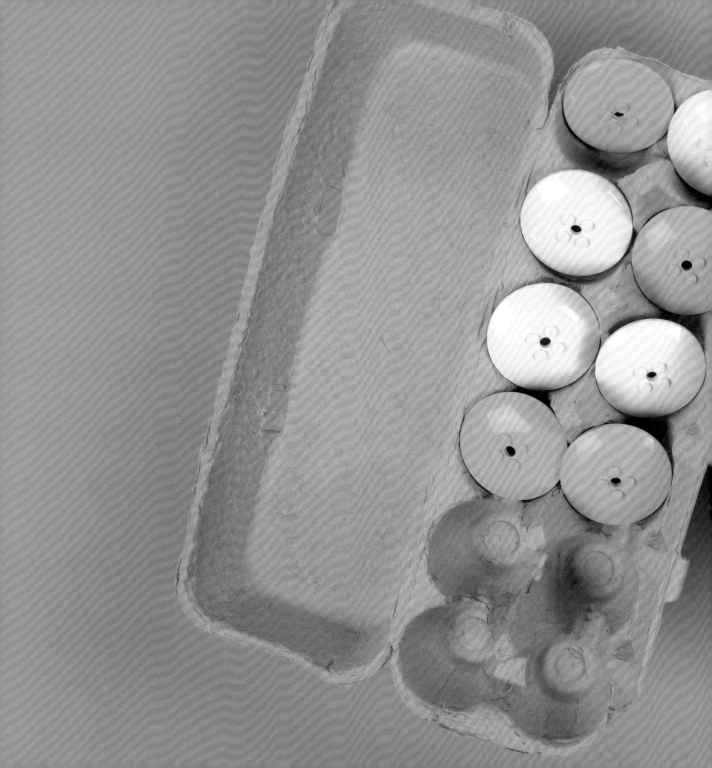

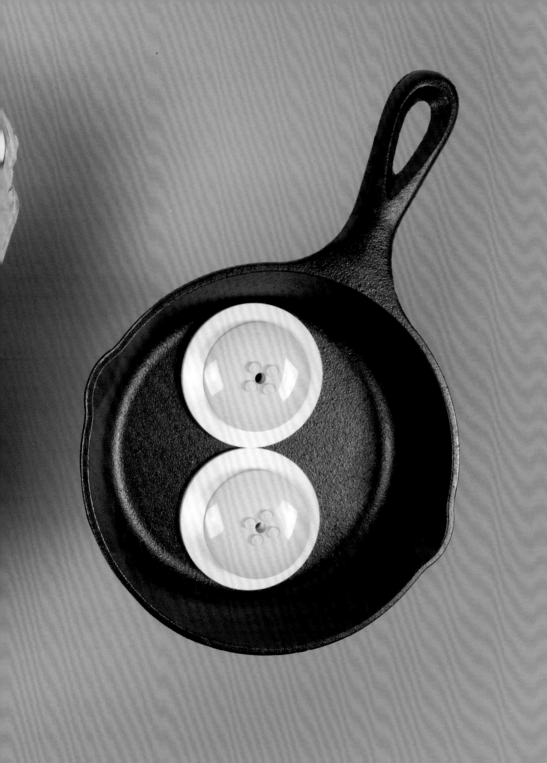

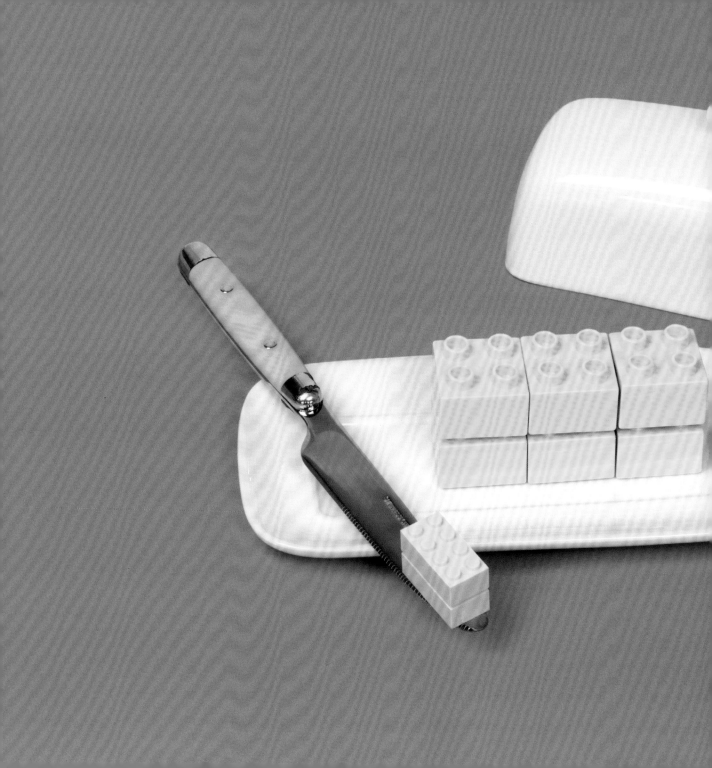

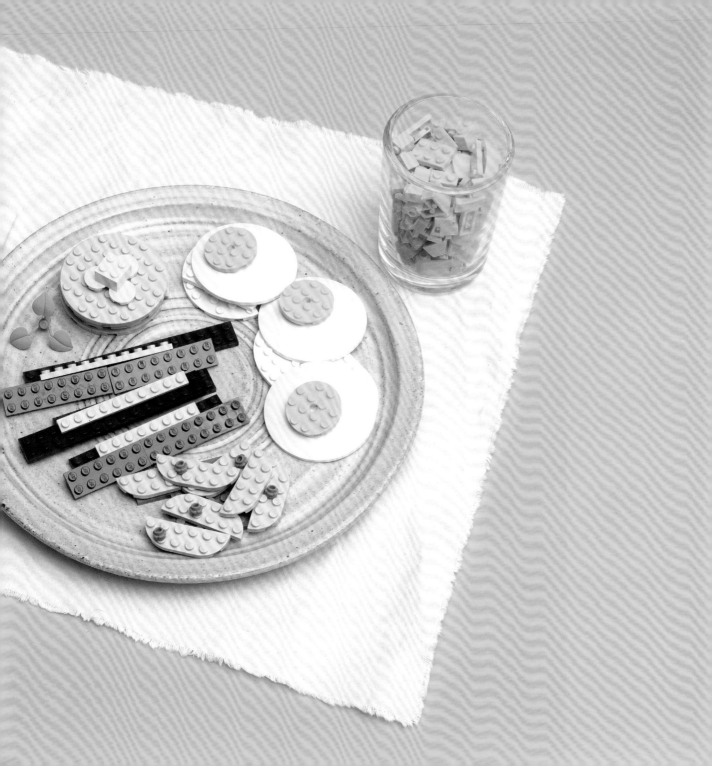

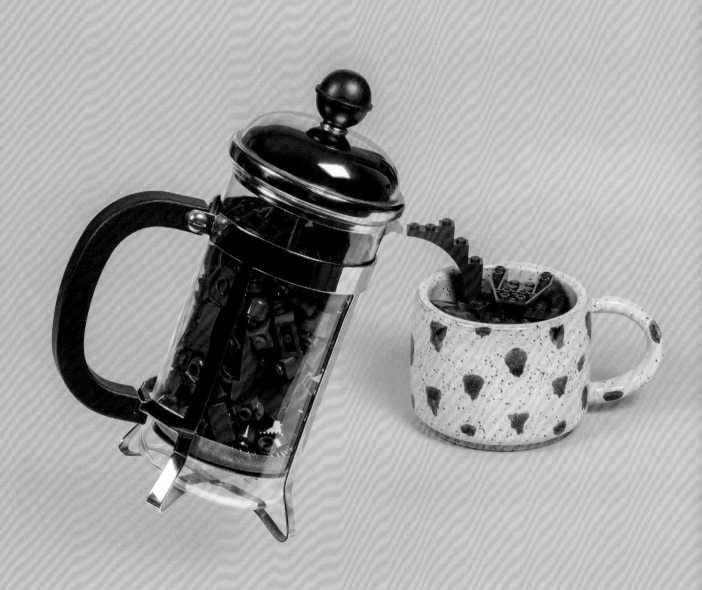

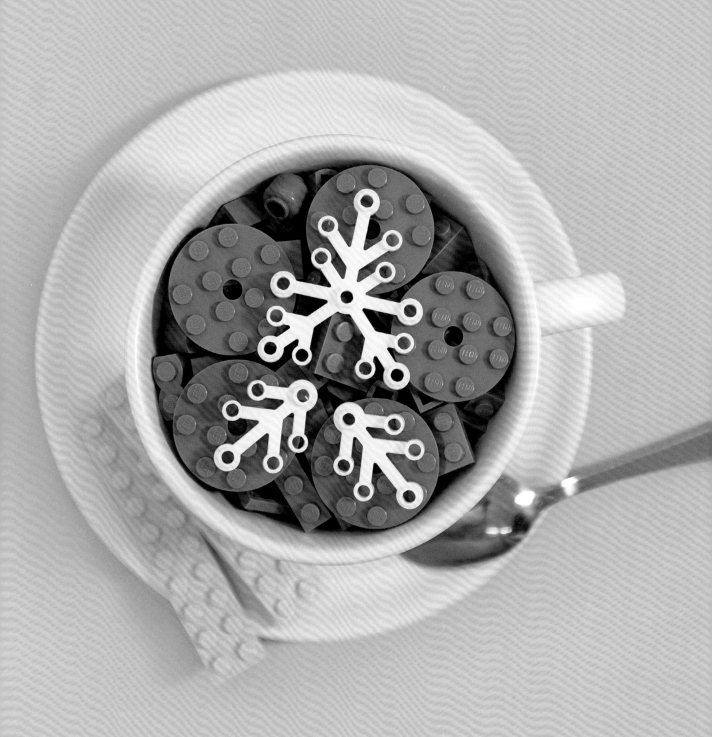

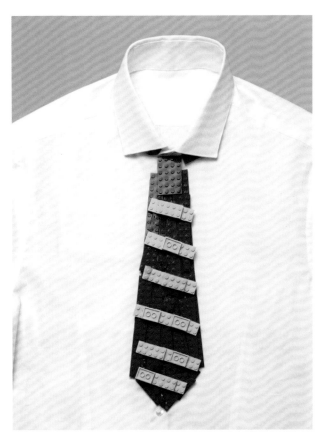
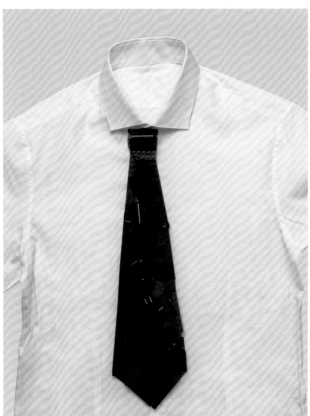

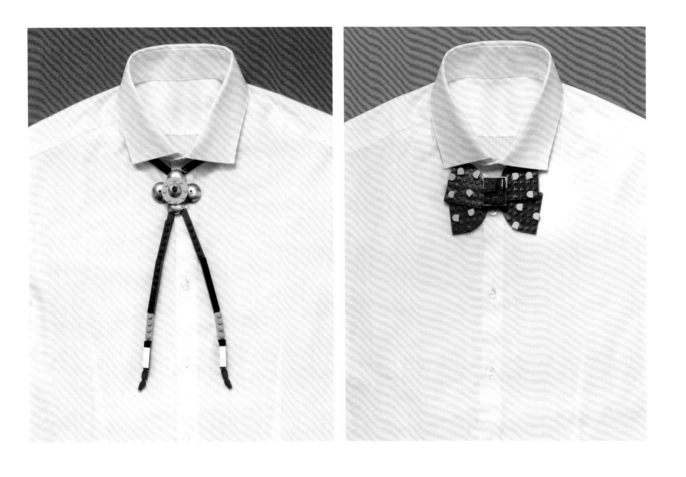

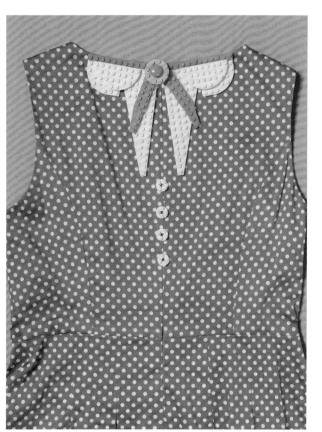
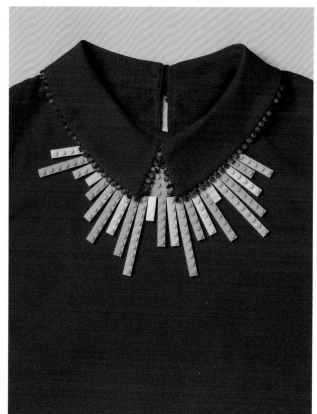

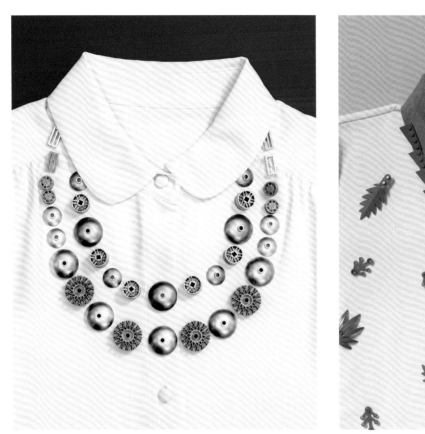
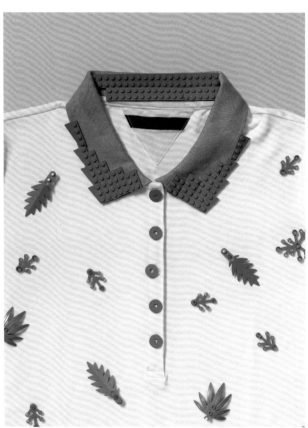

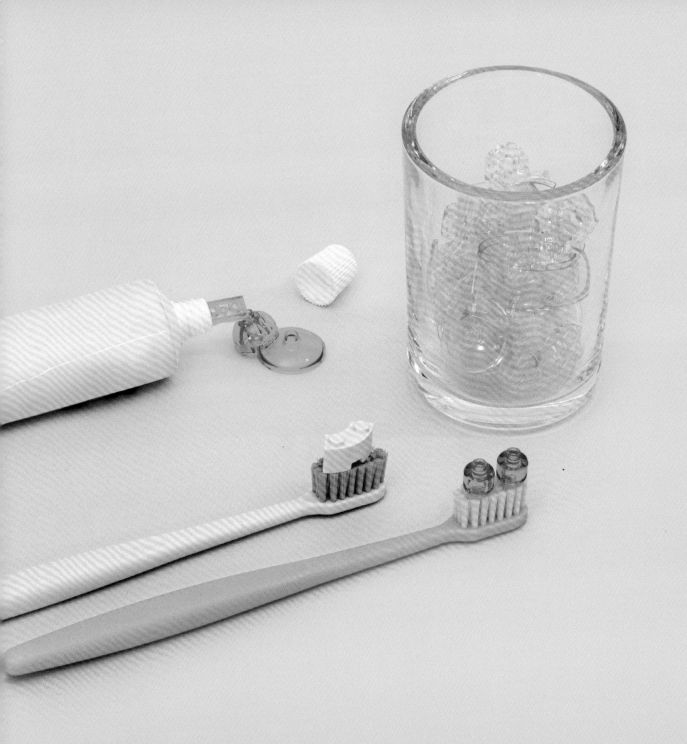

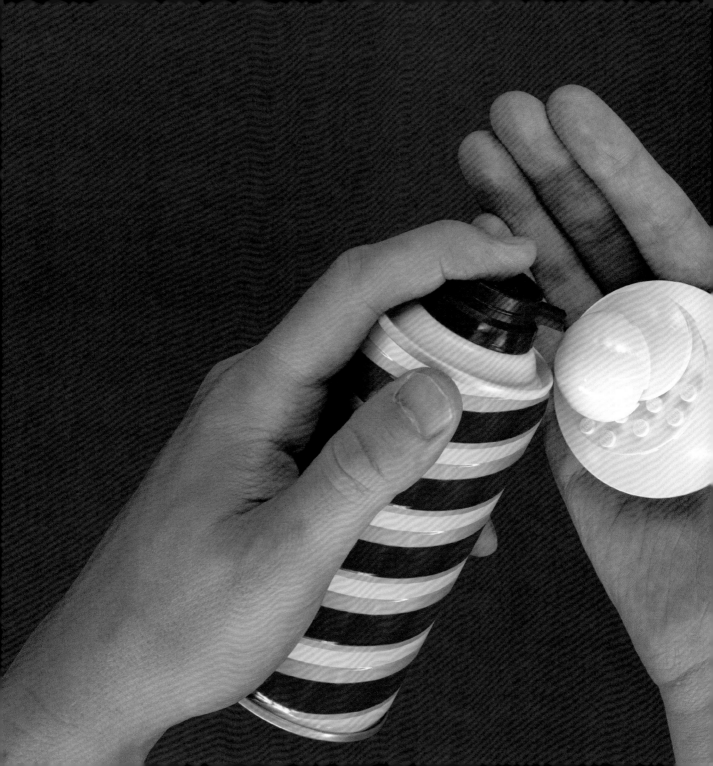

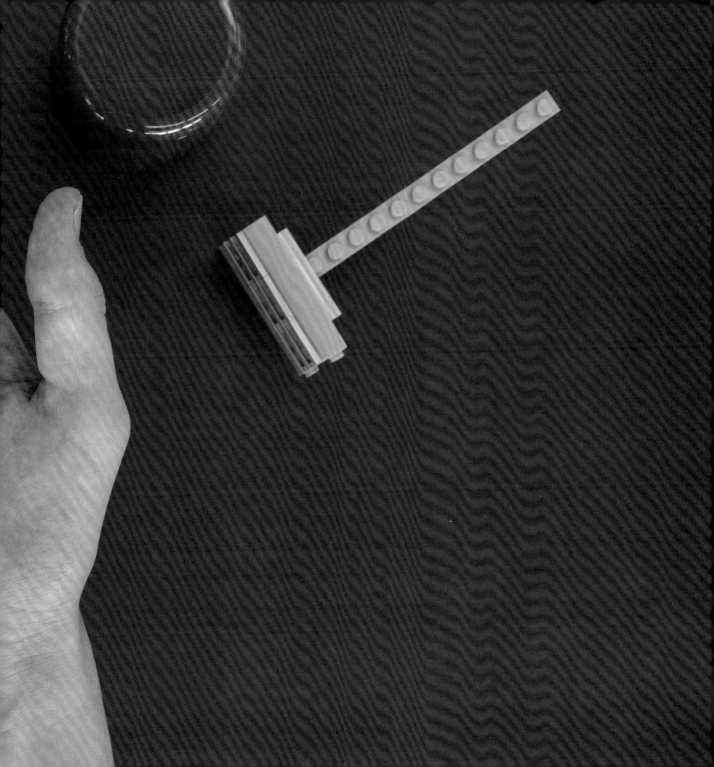

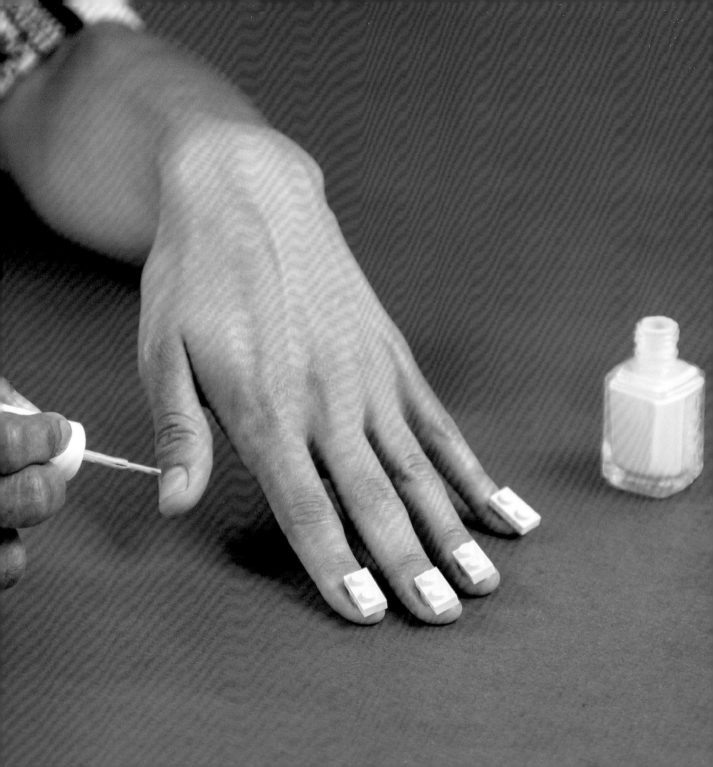

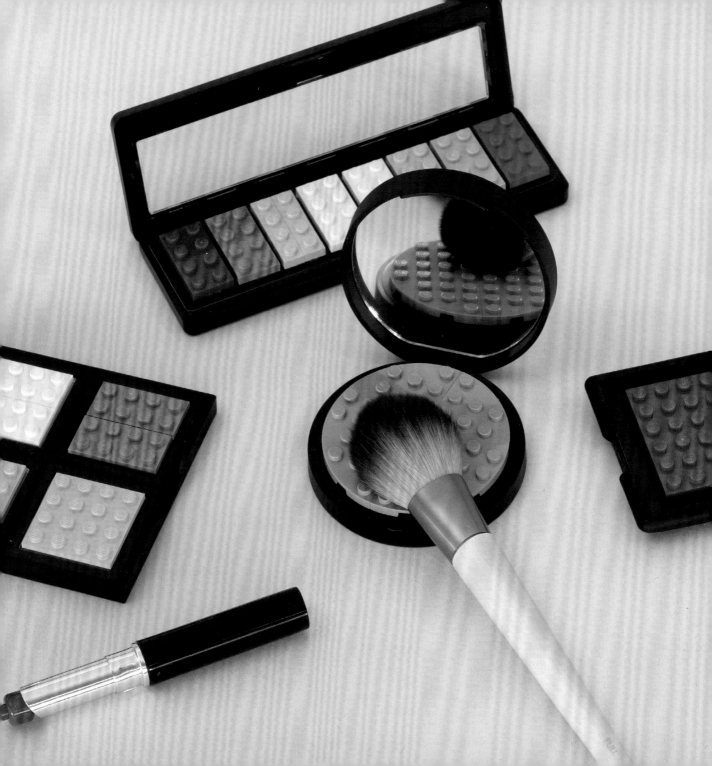

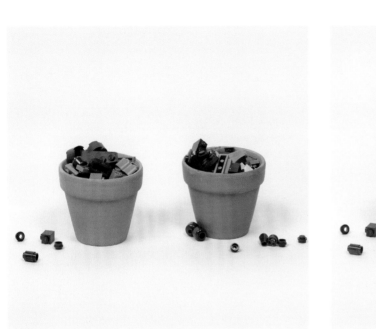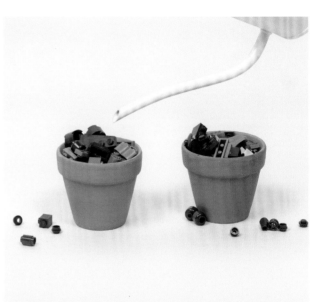

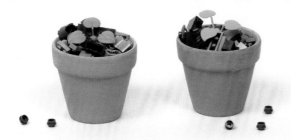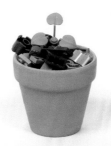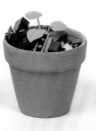

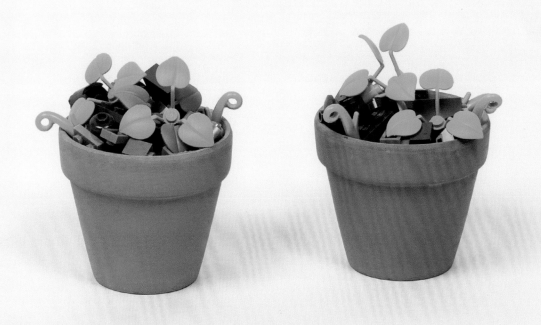

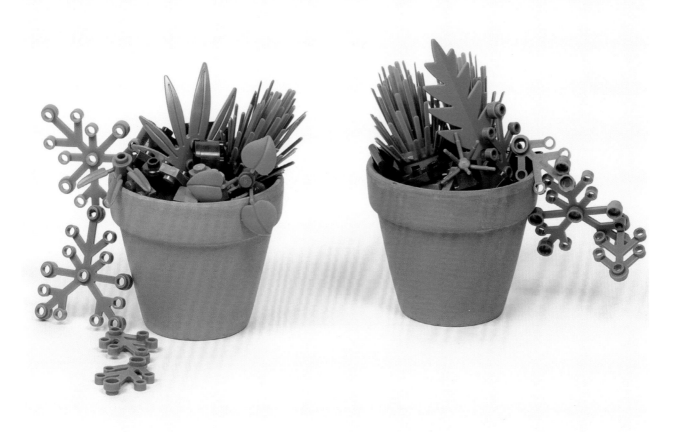

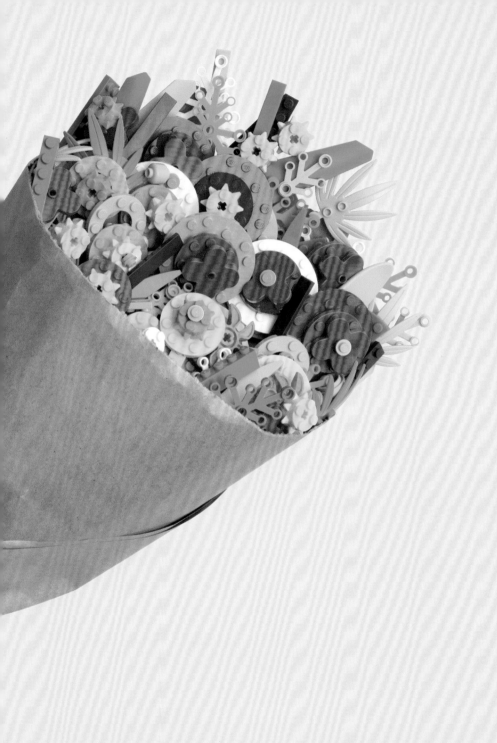

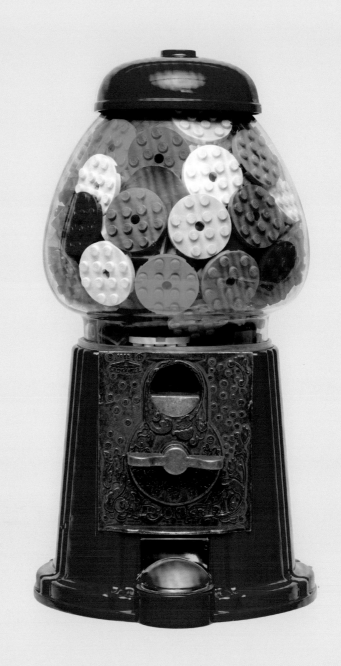

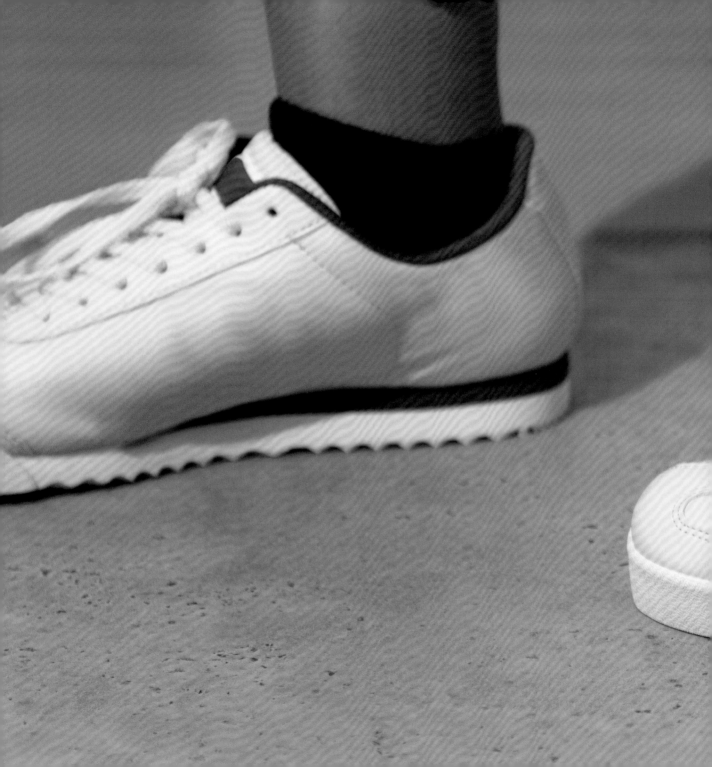

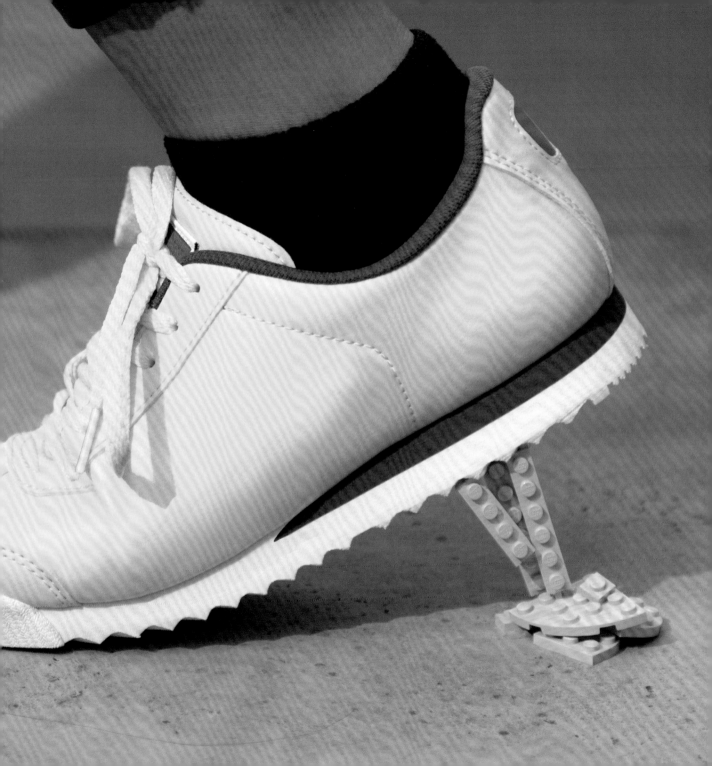

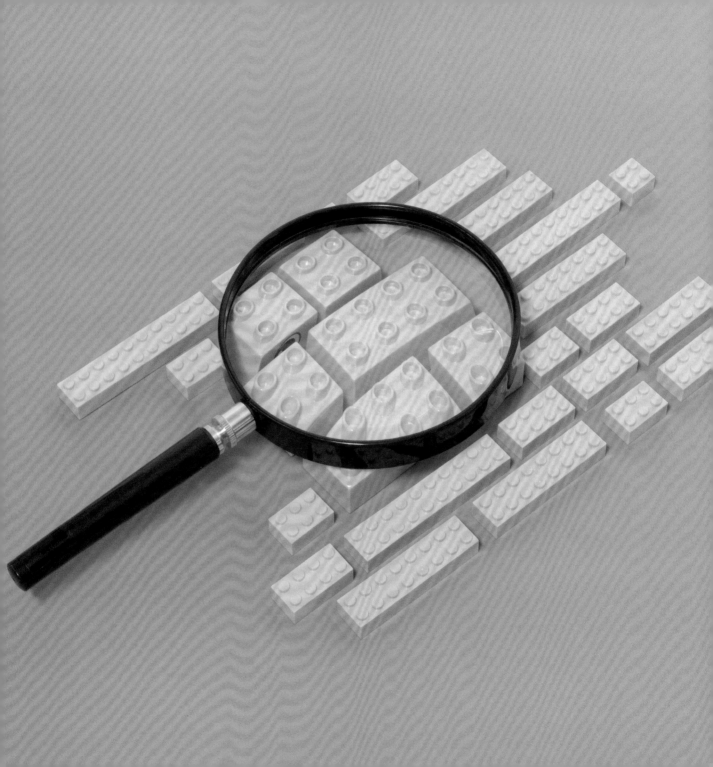

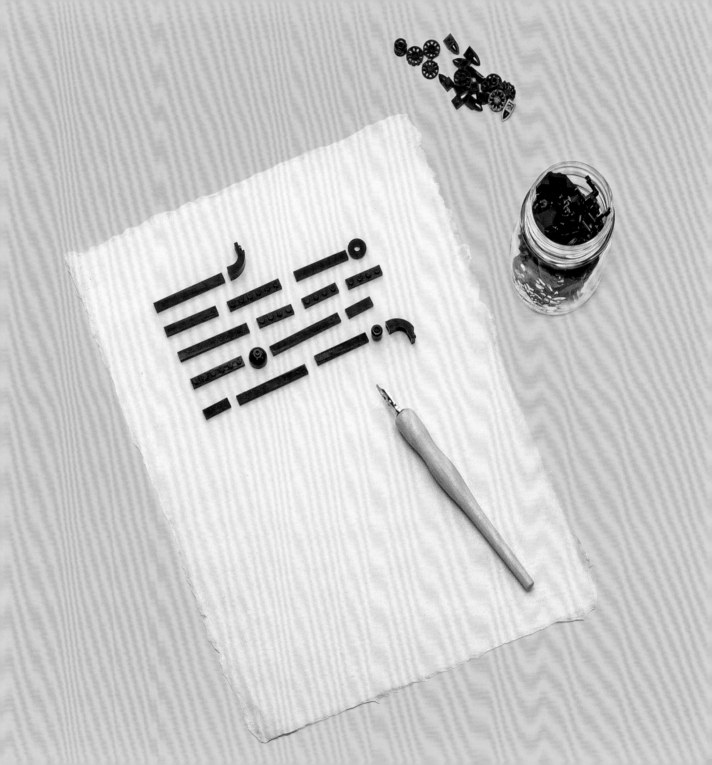

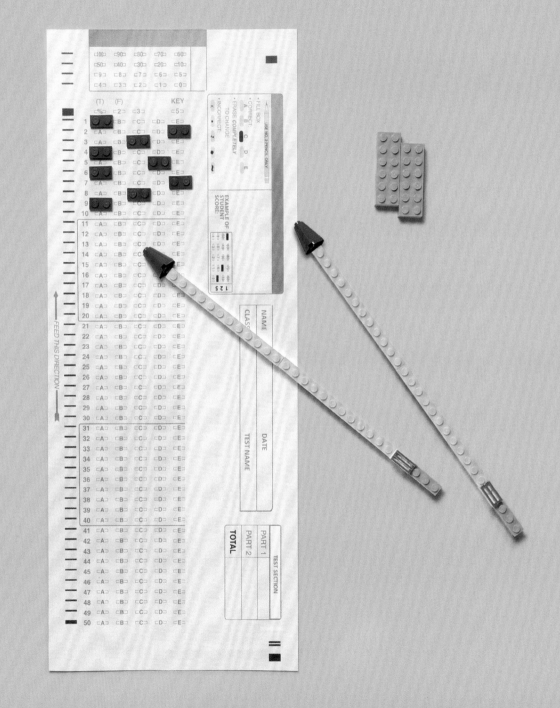

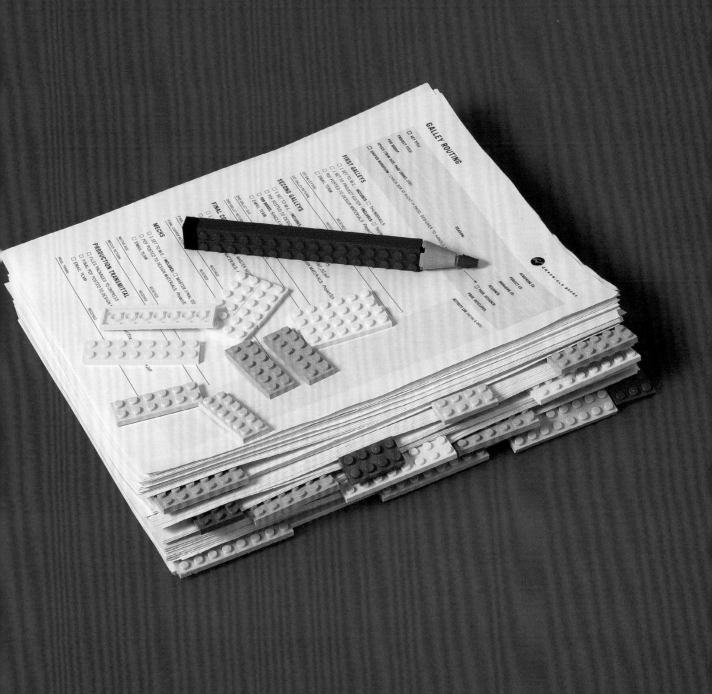

CYRANO

Ah, no, young sir!
You are too simple. Why, you might have said—
Oh, a great many things! Mon dieu, why waste
Your opportunity? For example, thus:—
AGGRESSIVE: I, sir, if that nose were mine,
I'd have it amputated—on the spot!
FRIENDLY: How do you drink with such a nose?
You ought to have a cup made specially.
DESCRIPTIVE: 'Tis a rock—a crag—a cape—
A cape? say rather, a peninsula!
INQUISITIVE: What is that receptacle—
A razor-case or a portfolio?
KINDLY: Ah, do you love the little birds
So much that when they come and sing to you,
You give them this to perch on? INSOLENT:
Sir, when you smoke, the neighbors must suppose
Your chimney is on fire. CAUTIOUS: Take care—
A weight like that might make you topheavy.
THOUGHTFUL: Somebody fetch my parasol—
Those delicate colors fade so in the sun!
PEDANTIC: Does not Aristophanes
Mention a mythologic monster called
Hippocampelephantocamelos?
Surely we have here the original!
FAMILIAR: Well, old torchlight! Hang your hat
Over that chandelier—it hurts my eyes.
ELOQUENT: When it blows, the typhoon howls,
And the clouds darken. DRAMATIC: When it bleeds—
The Red Sea! ENTERPRISING: What a sign
For some perfumer! LYRIC: Hark—the horn
Of Roland calls to summon Charlemagne!—
SIMPLE: When do they unveil the monument?
RESPECTFUL: Sir, I recognize in you
A man of parts, a man of prominence—
RUSTIC: Hey? What? Call that a nose? Na, na—

I be no fool like what you think I be—
That there's a blue cucumber! MILITARY: Why not
Point against cavalry! PRACTICAL: Why not
A lottery with this for the grand prize?
Or—parodying Faustus in the play—
"Was this the nose that launched a thousand ships
And burned the topless towers of Ilium?"

...urse. But wit,—not so,
...tom—and of letters,
You need but three to write you down—an Ass.
Moreover,—if you had the invention, here
Before these folk to make a jest of me—
Be sure you would not then articulate
The twentieth part of half a syllable
Of the beginning! For I say these things
Lightly enough myself, about myself,
But I allow none else to utter them.

DE GUICHE

(Tries to lead away the amazed VALVERT)

Vicomte—come.

VALVERT

(Choking)

Oh— These arrogant grand
A clown who—look at him—not even gloves
No ribbons—no lace—no buckles on his shoes

CYRANO

But inwardly, I keep my daintiness.
I do not bear with me, by any chance,
An insult not yet washed away—a conscie...
Yellow with unpurged bile—an honor fra...
To rags, a set of scruples badly worn,
I go caparisoned in gems unseen,

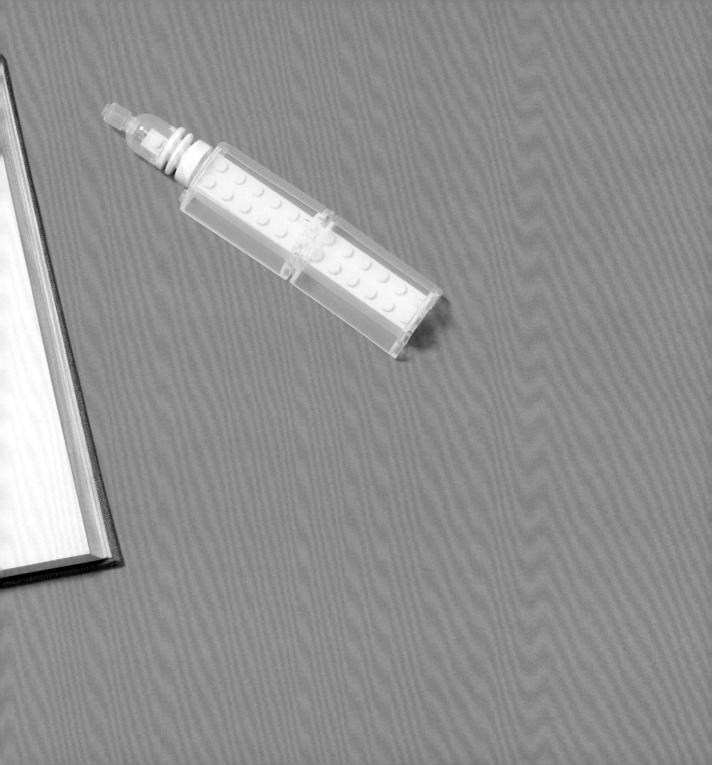

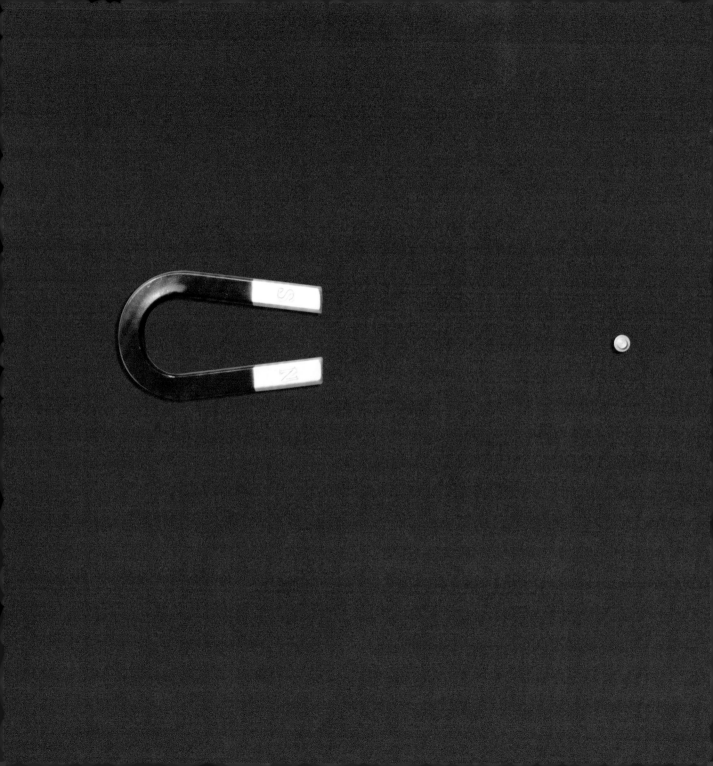

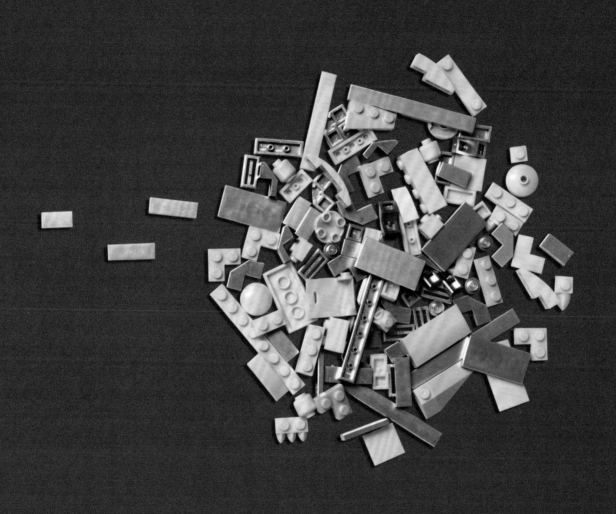

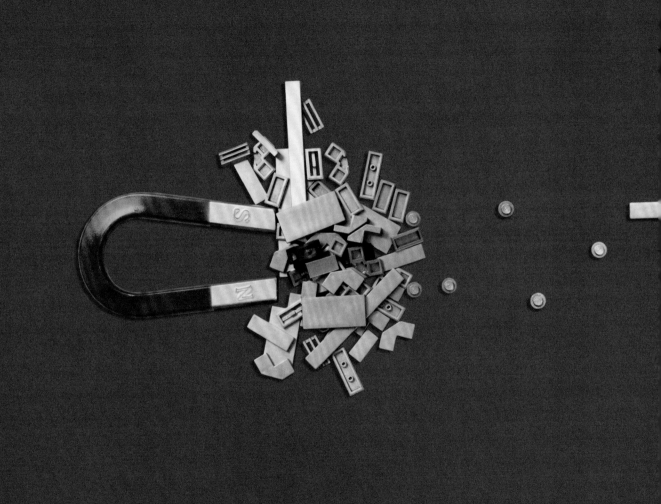

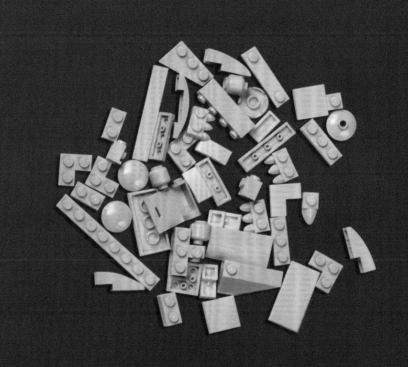

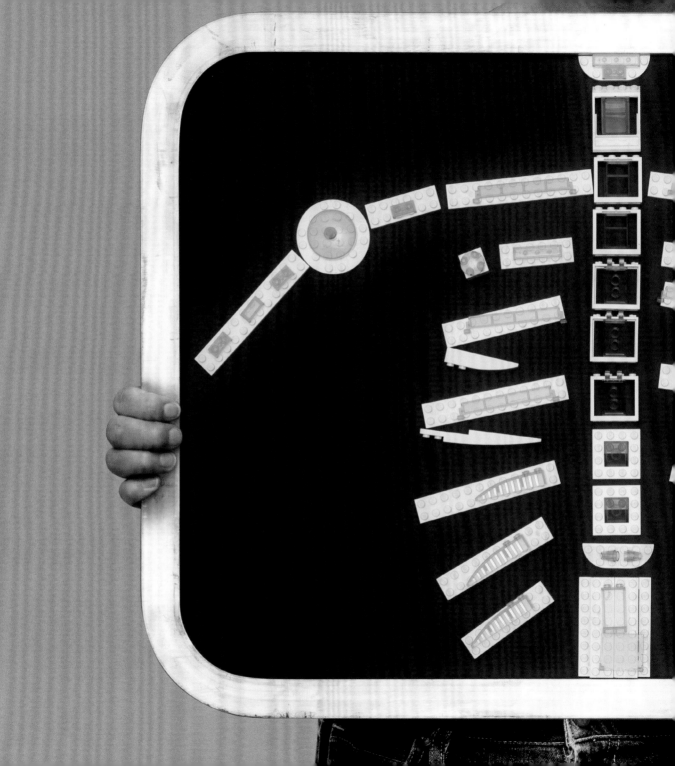

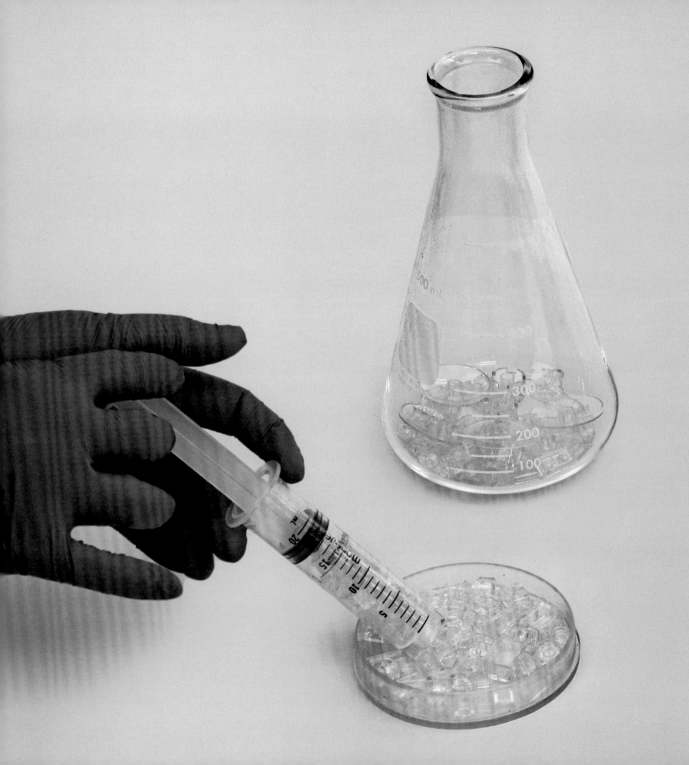

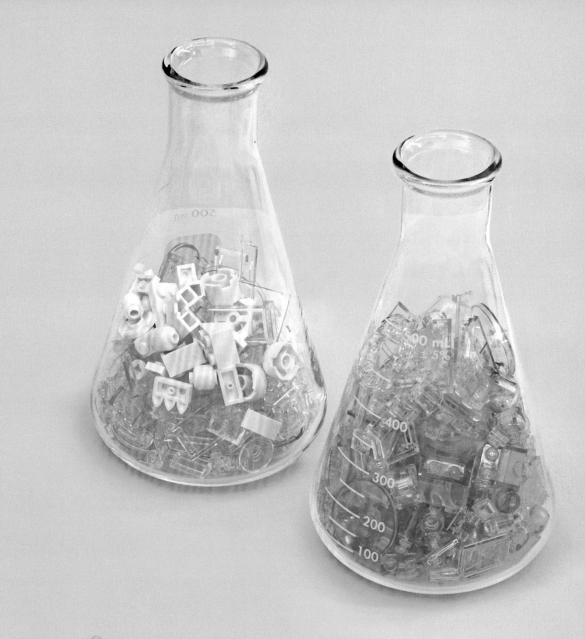

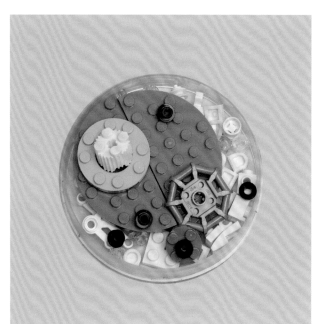

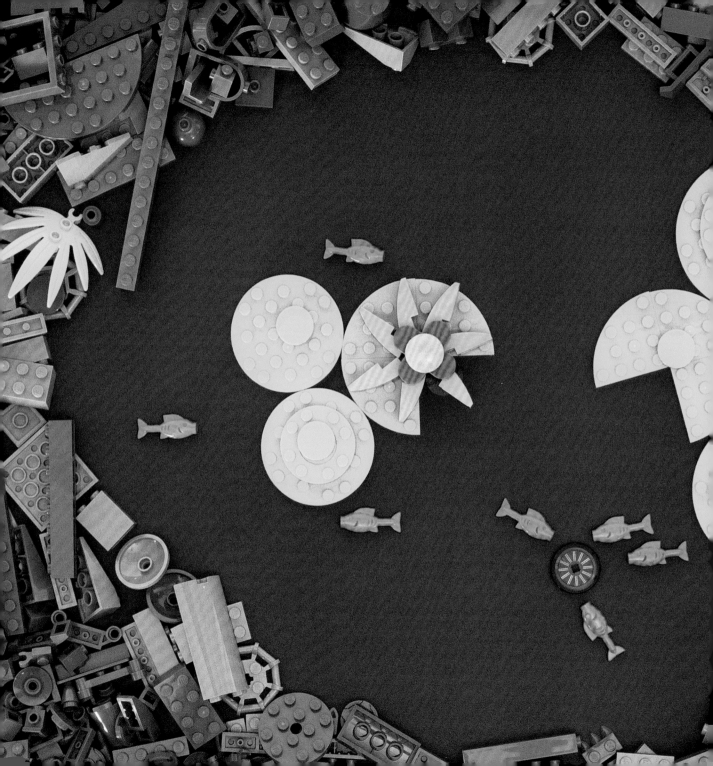

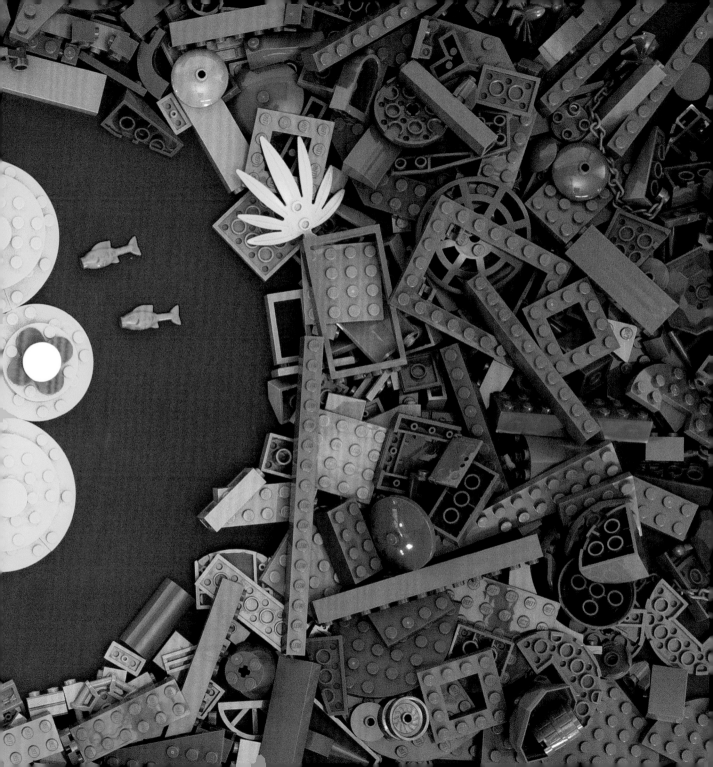

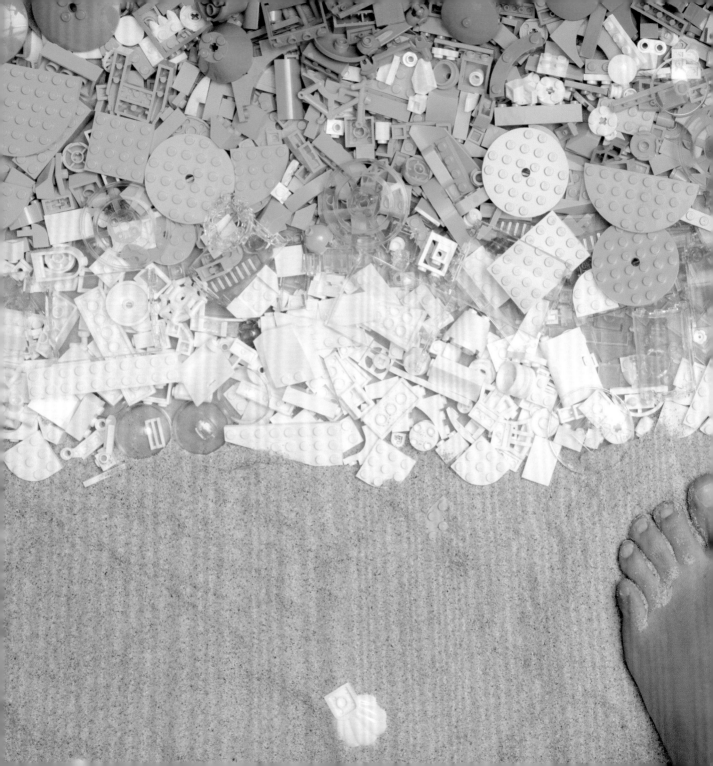

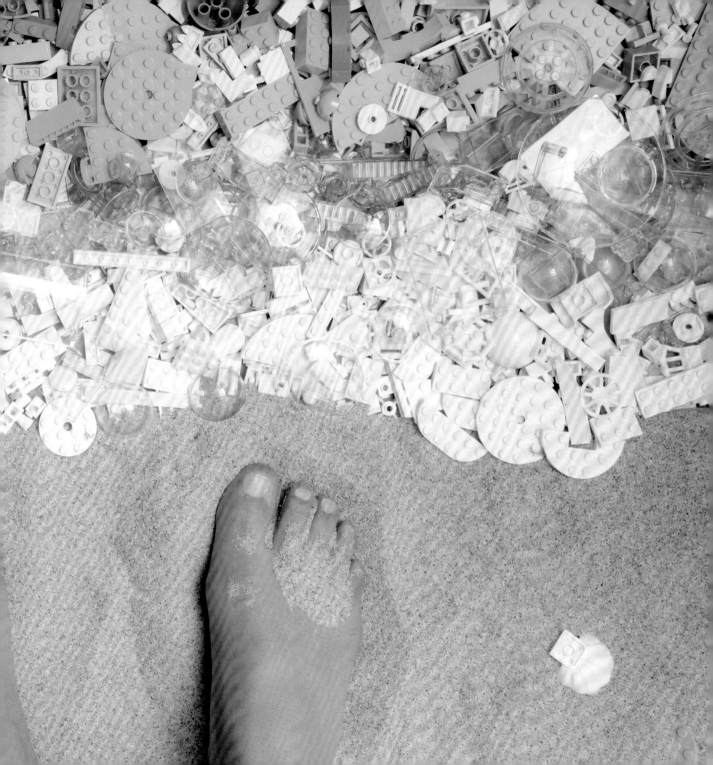

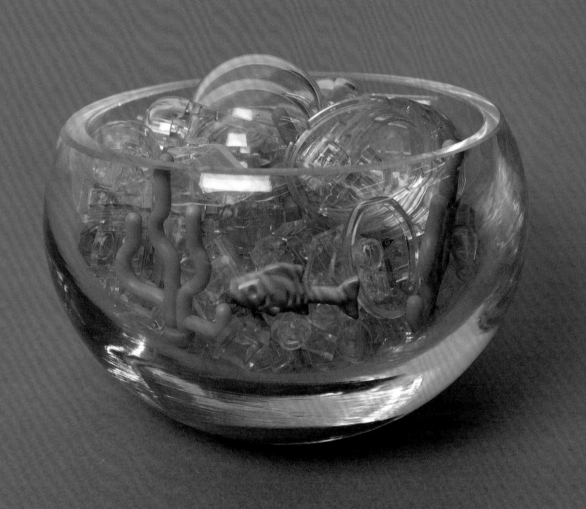

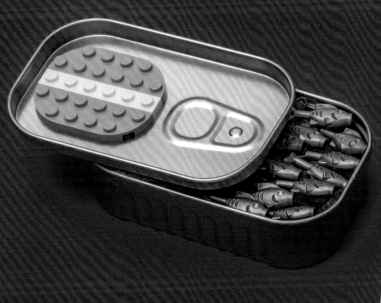
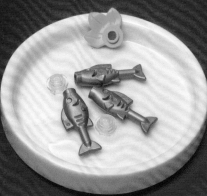

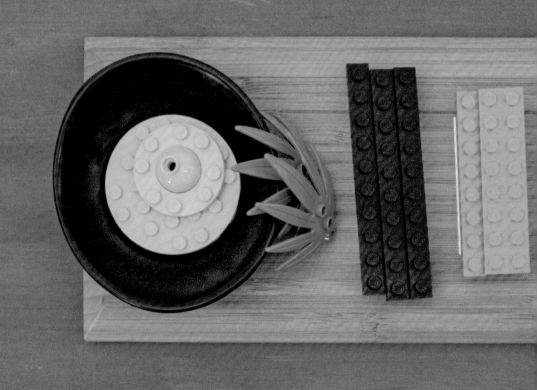

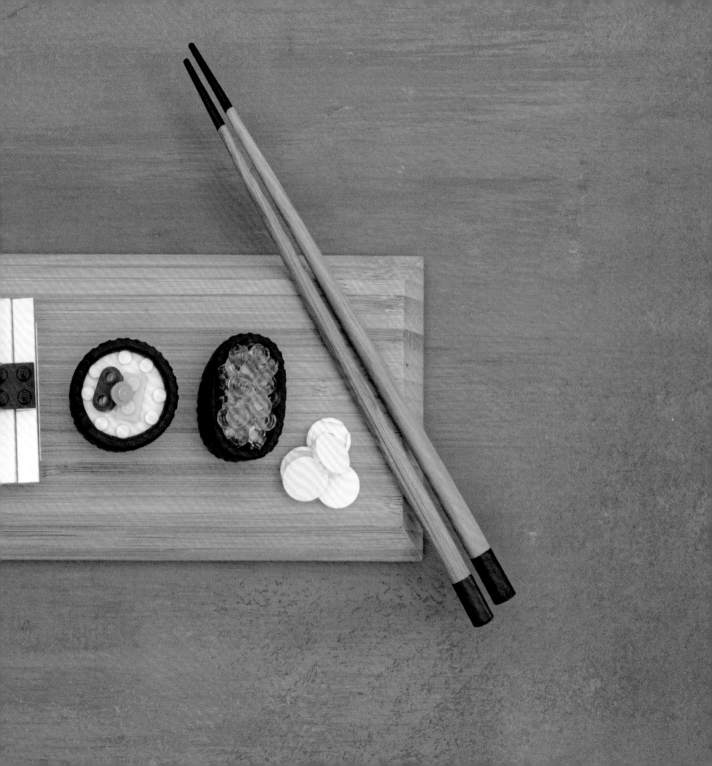

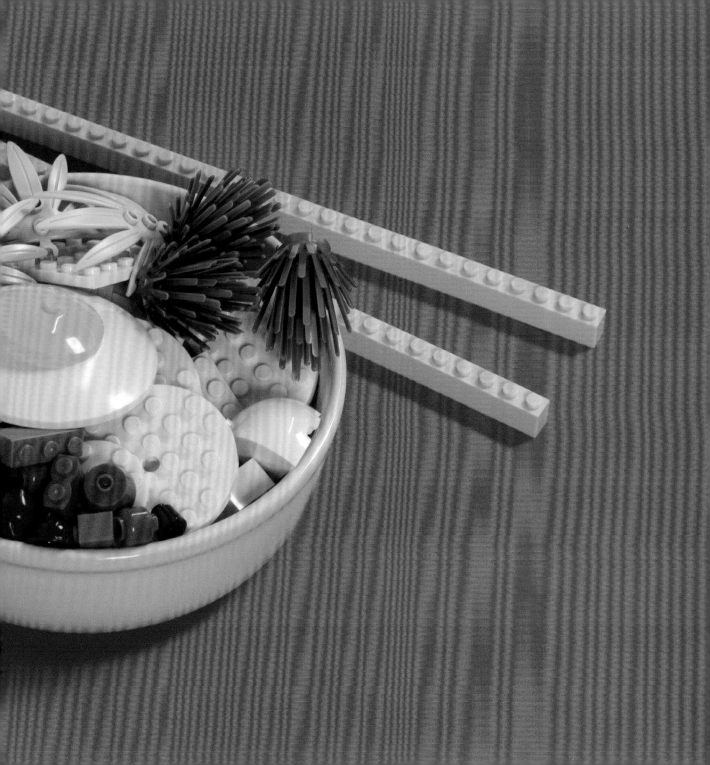

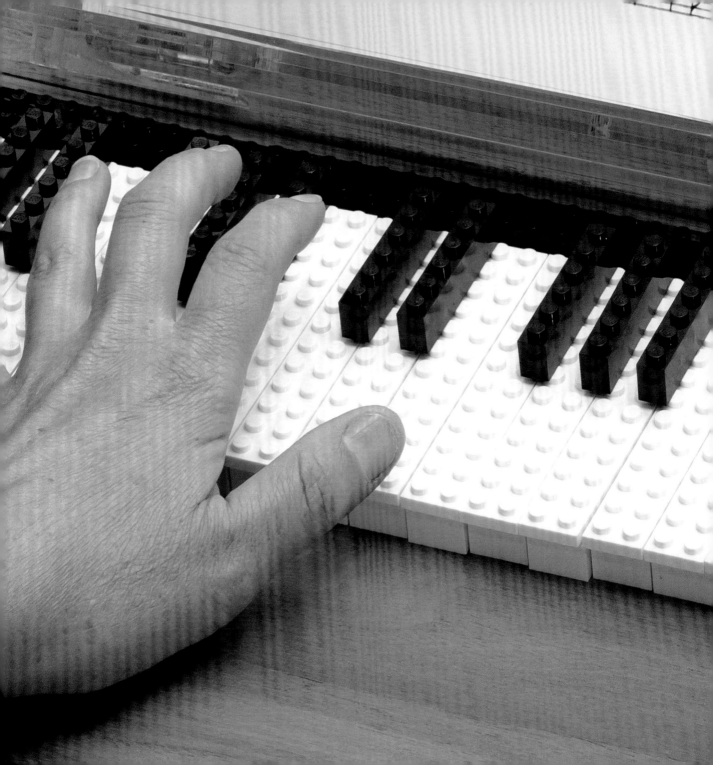

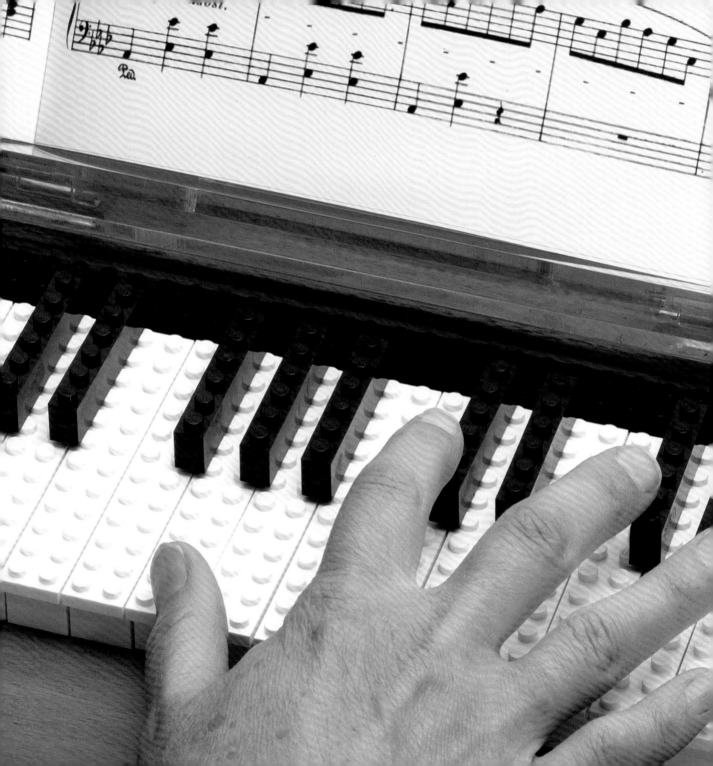

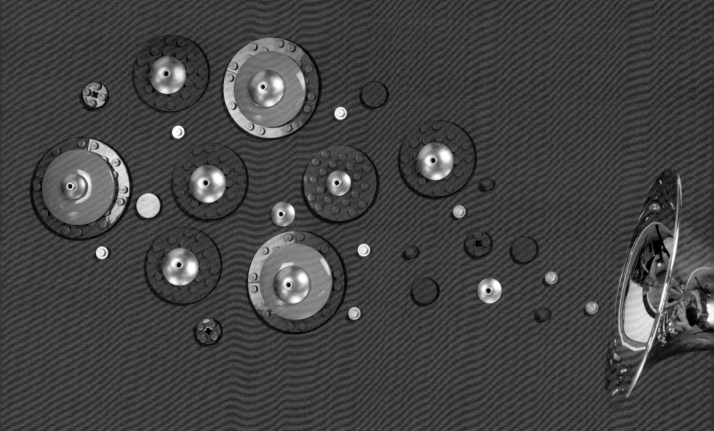

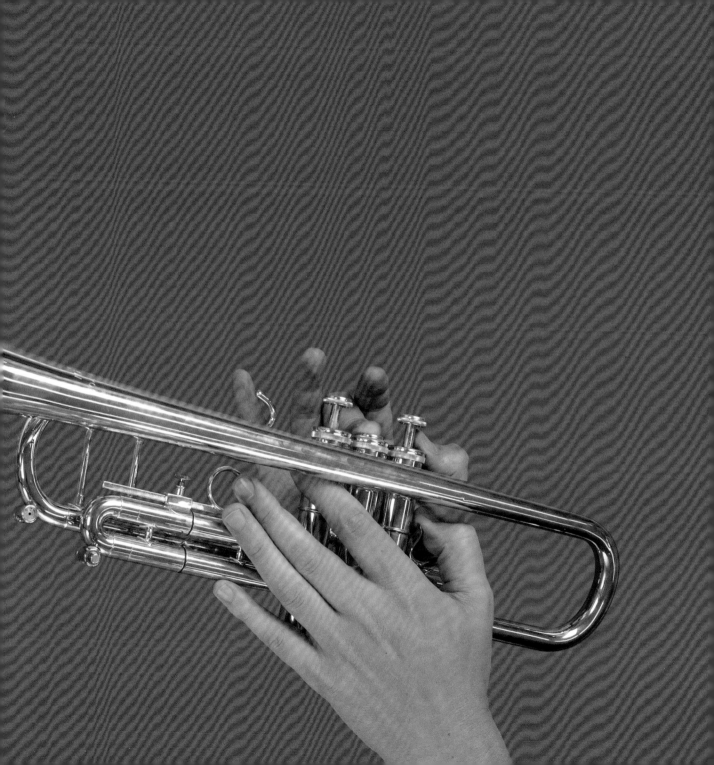

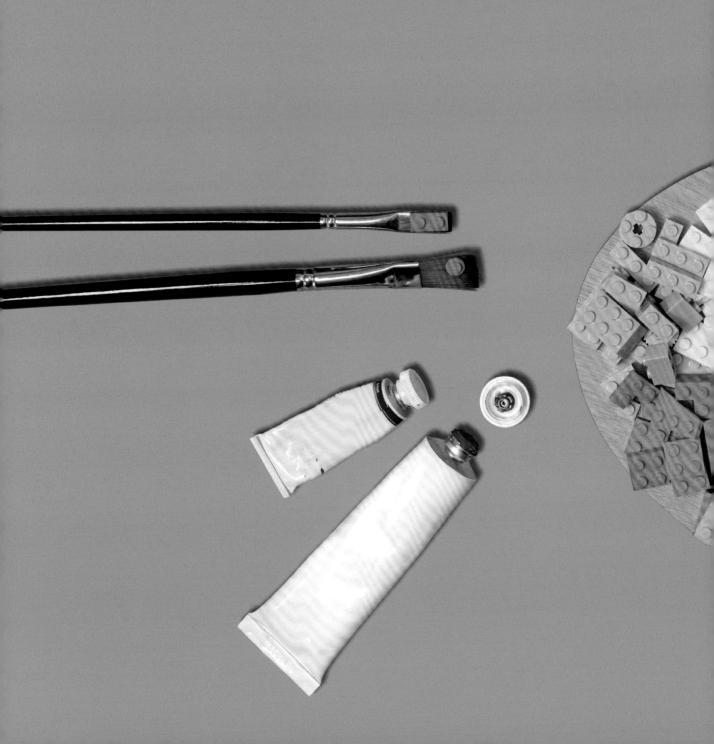

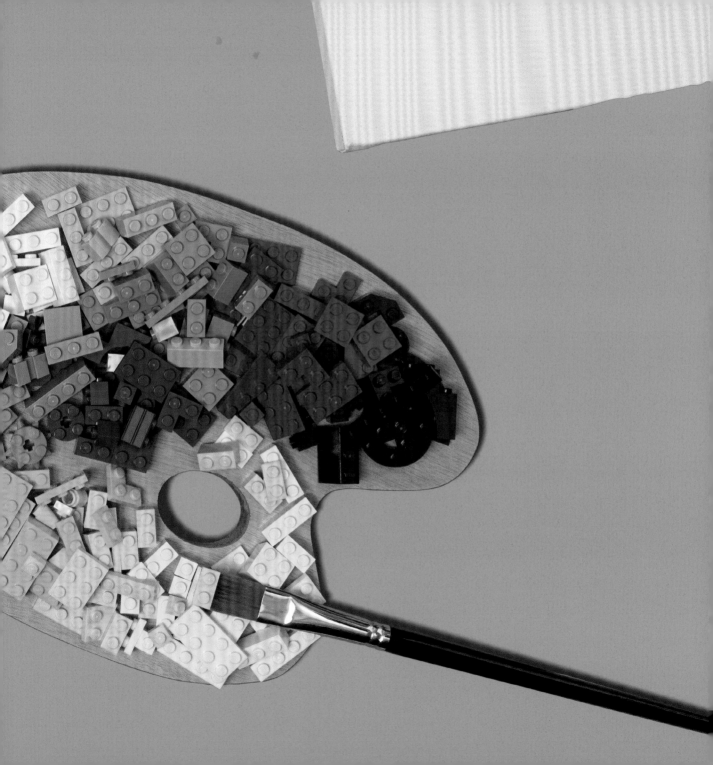

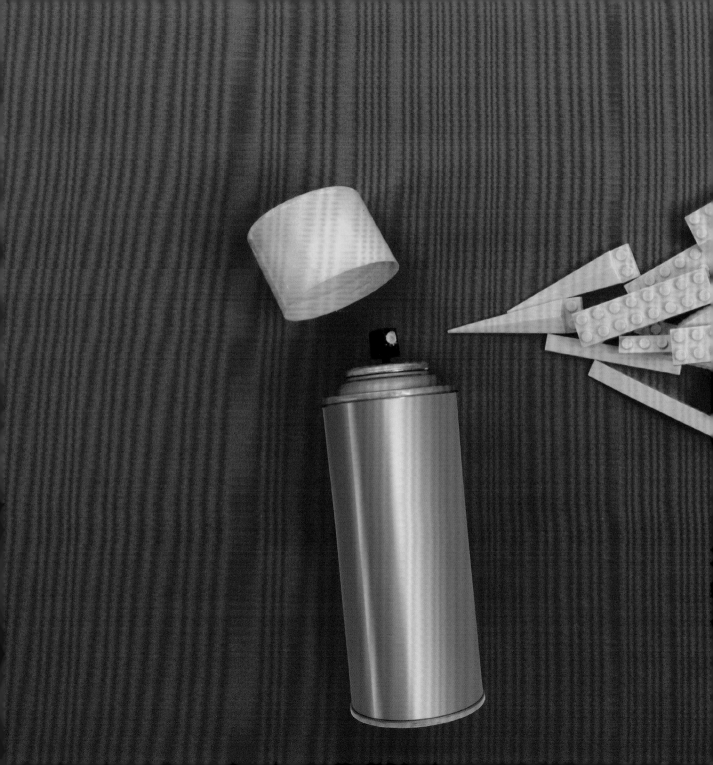

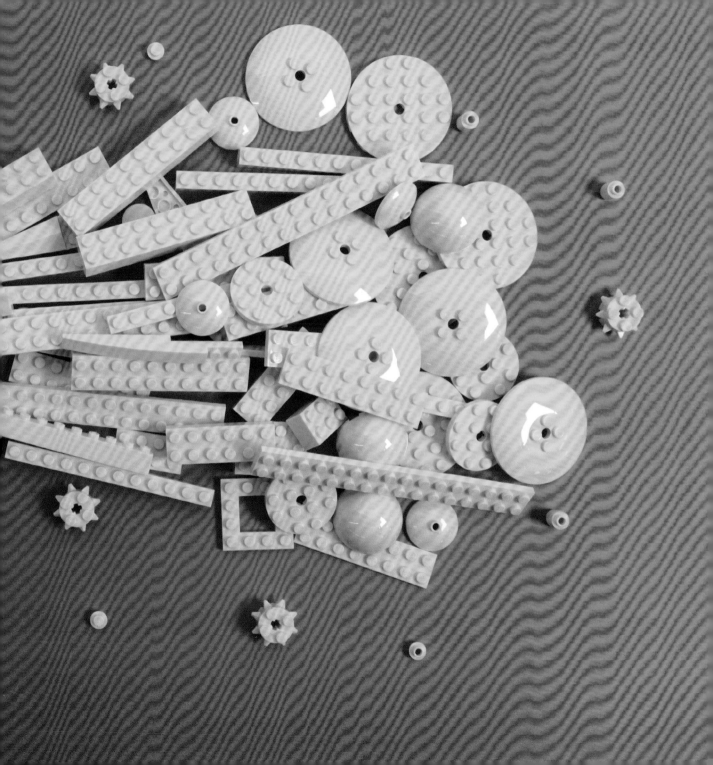

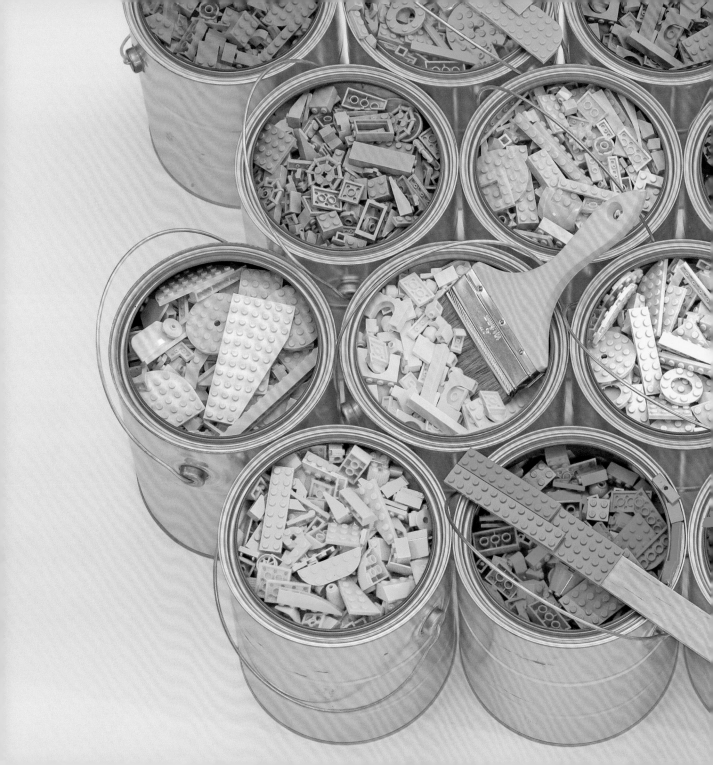

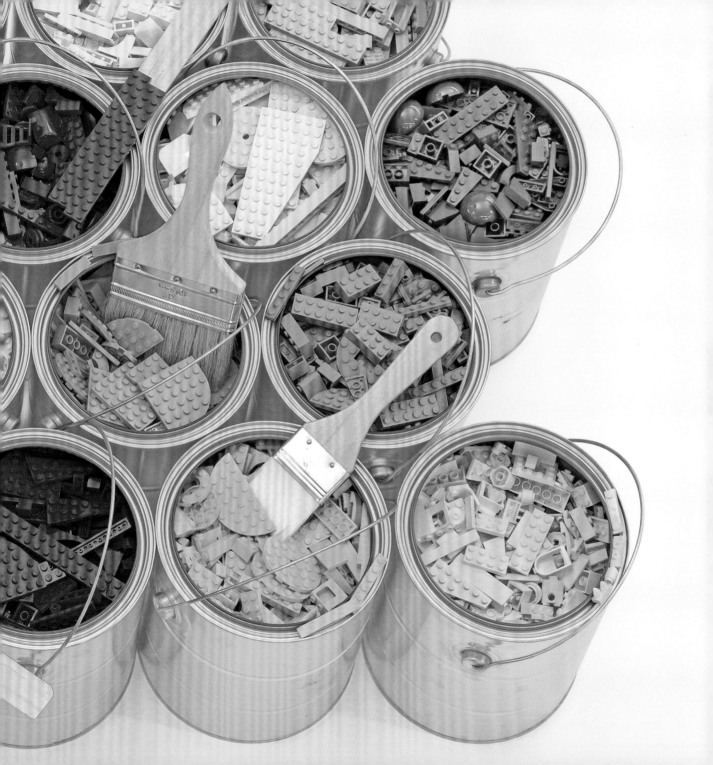

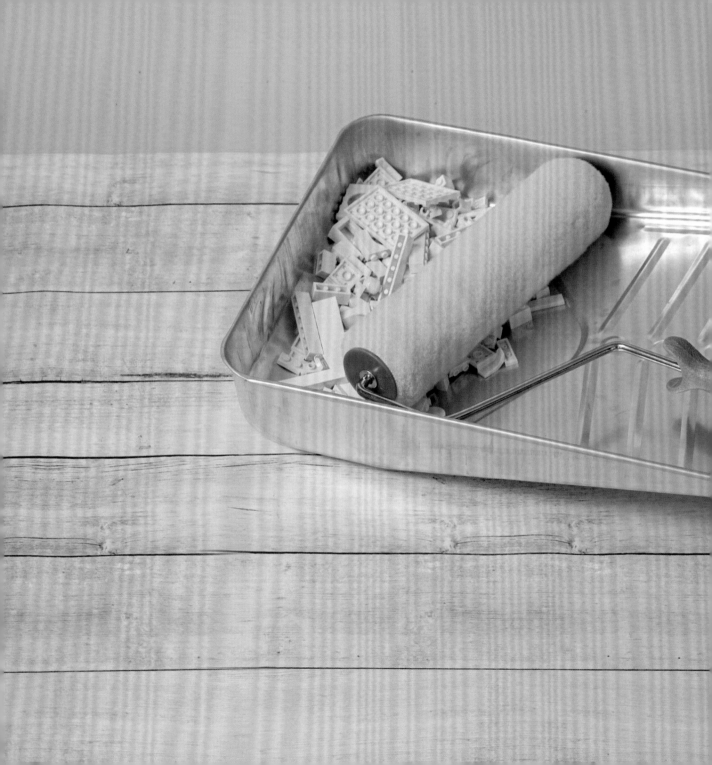

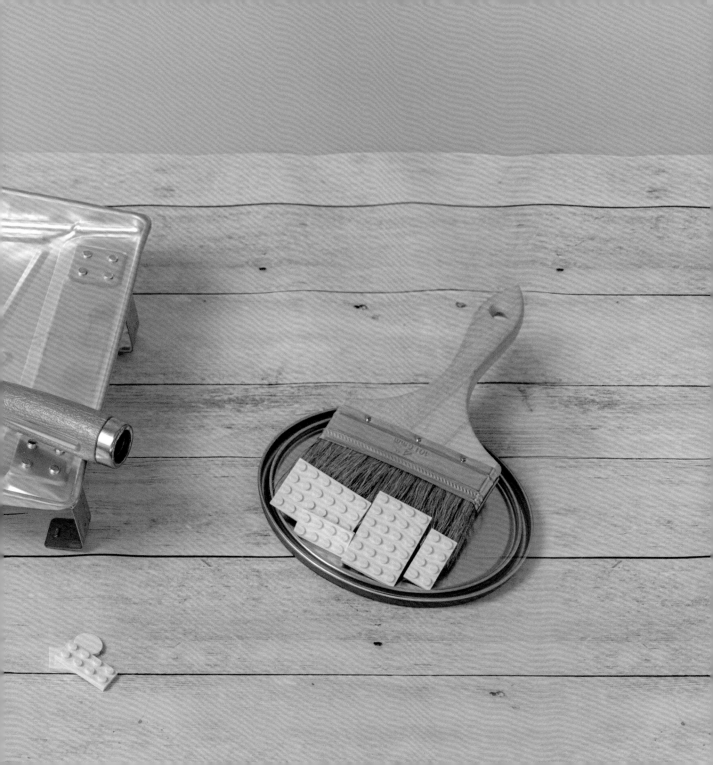

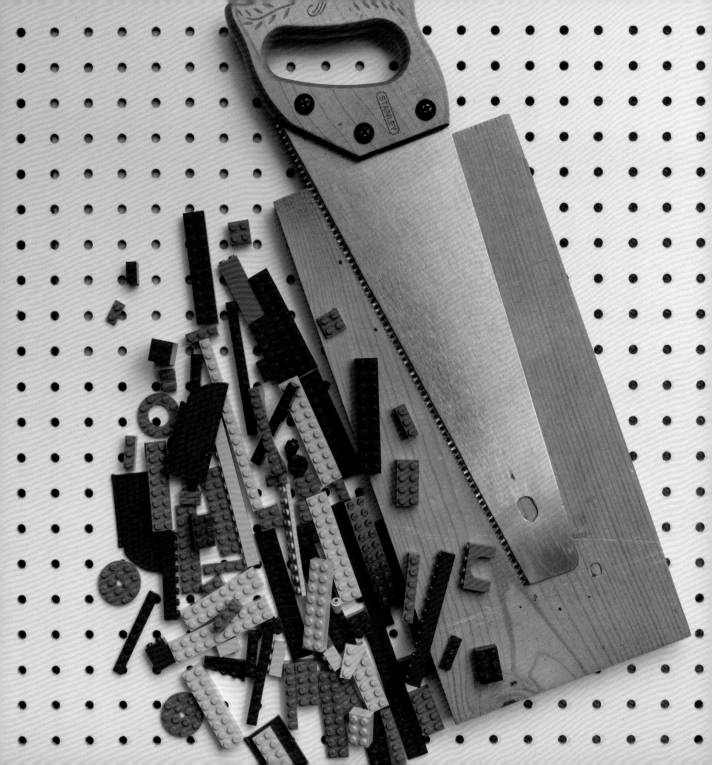

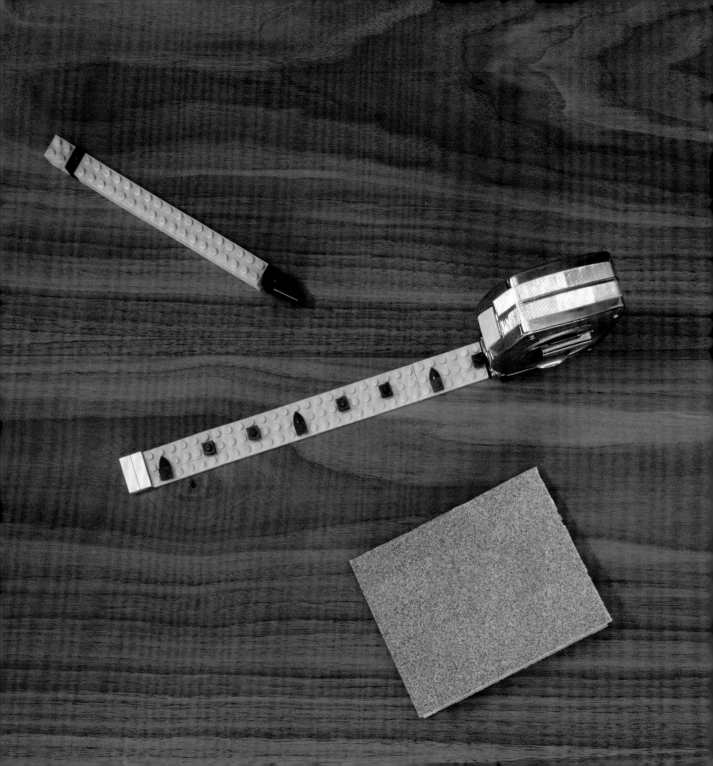

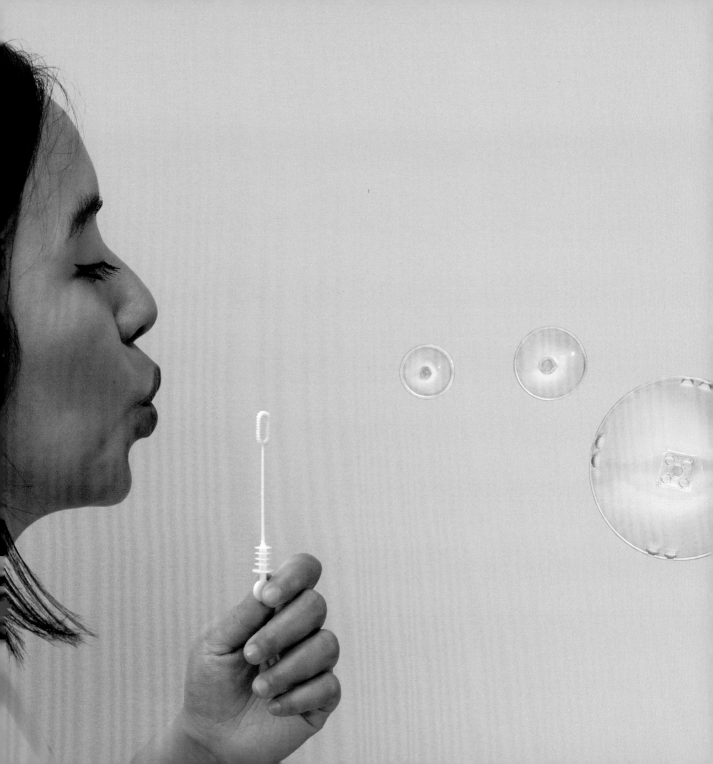

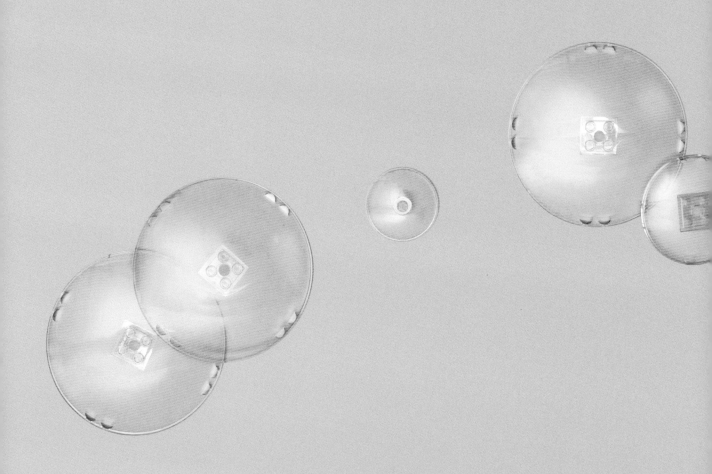

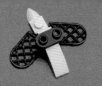
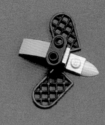
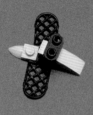
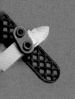

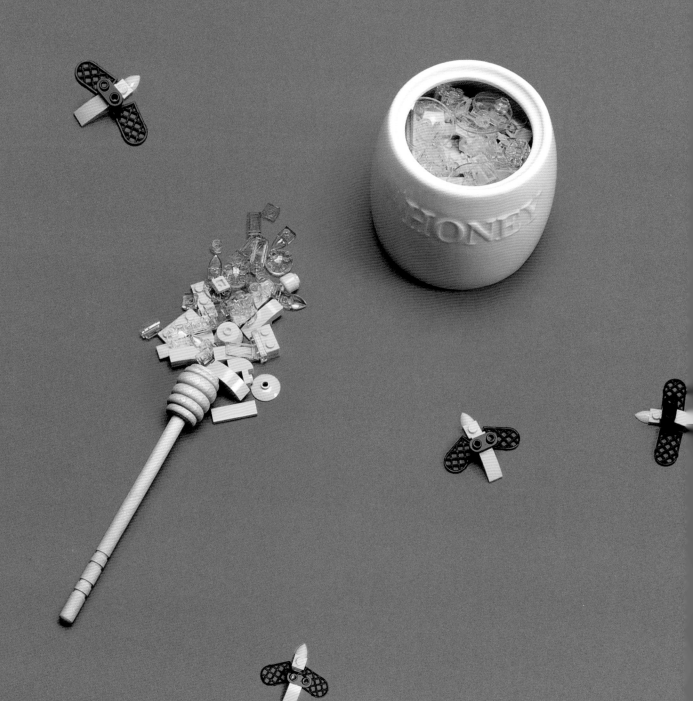

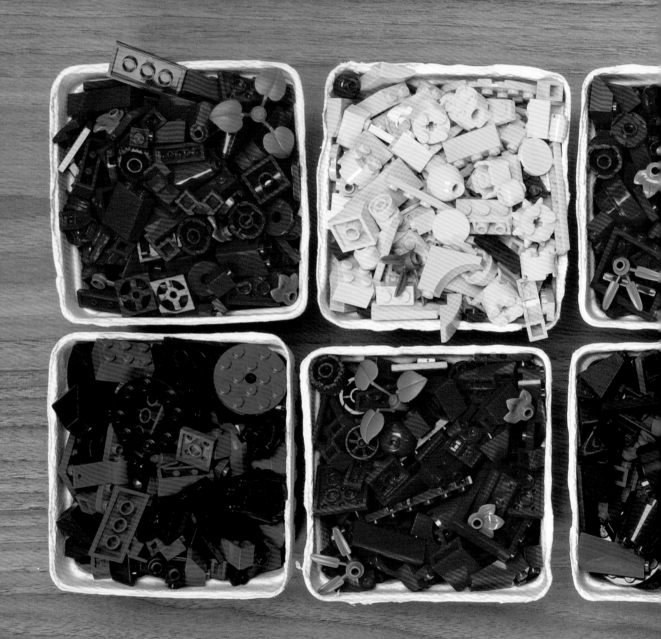

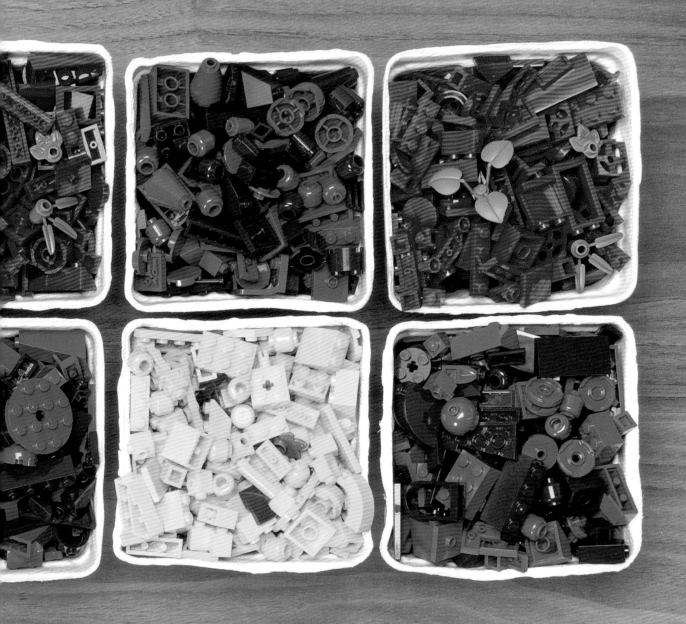

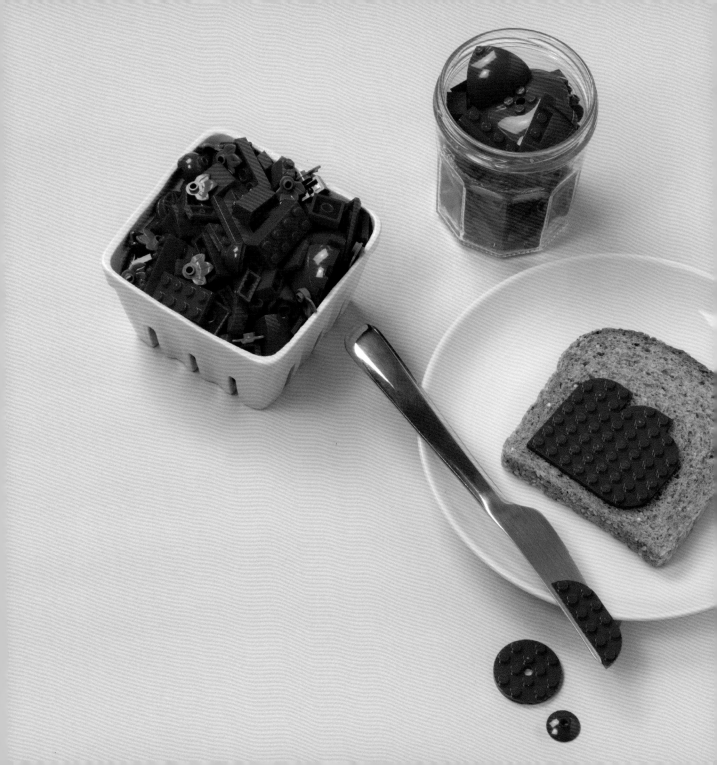

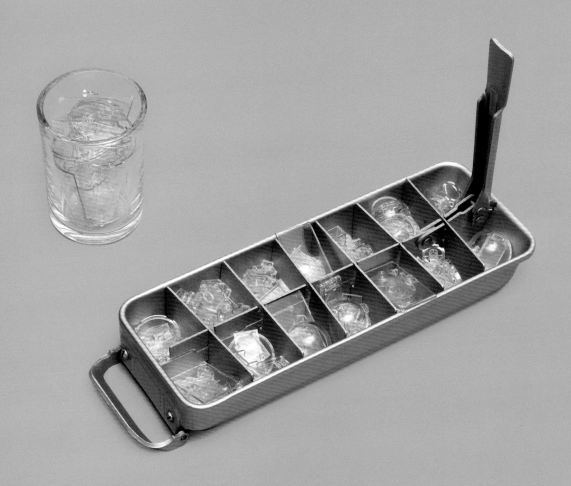

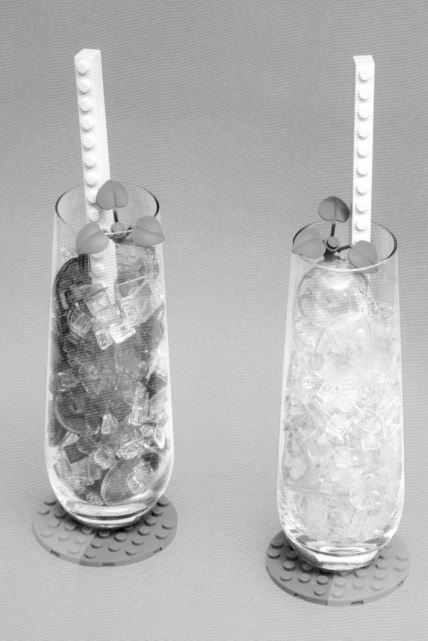

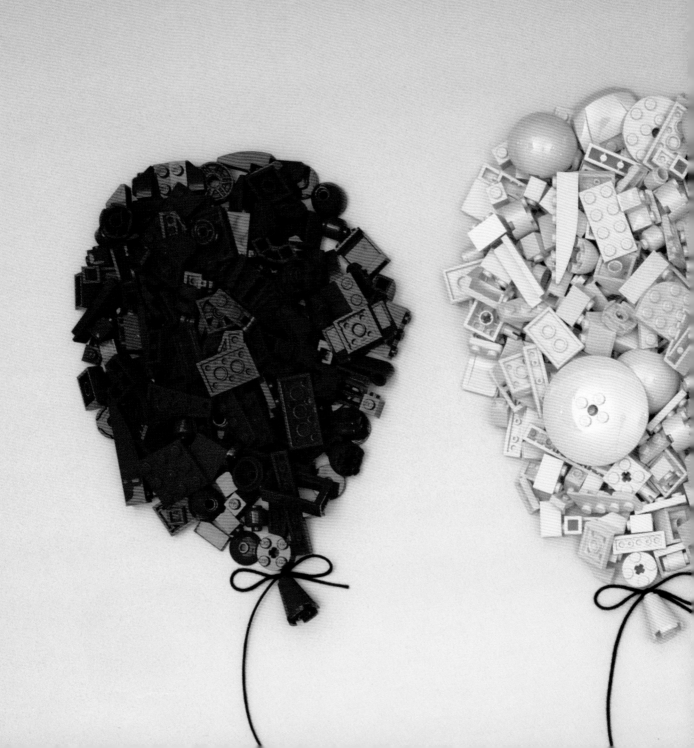

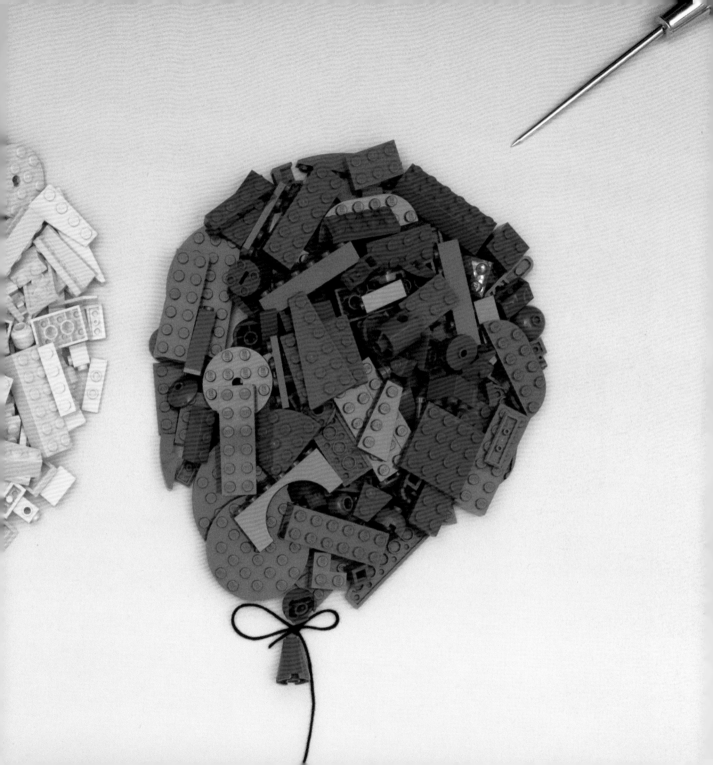

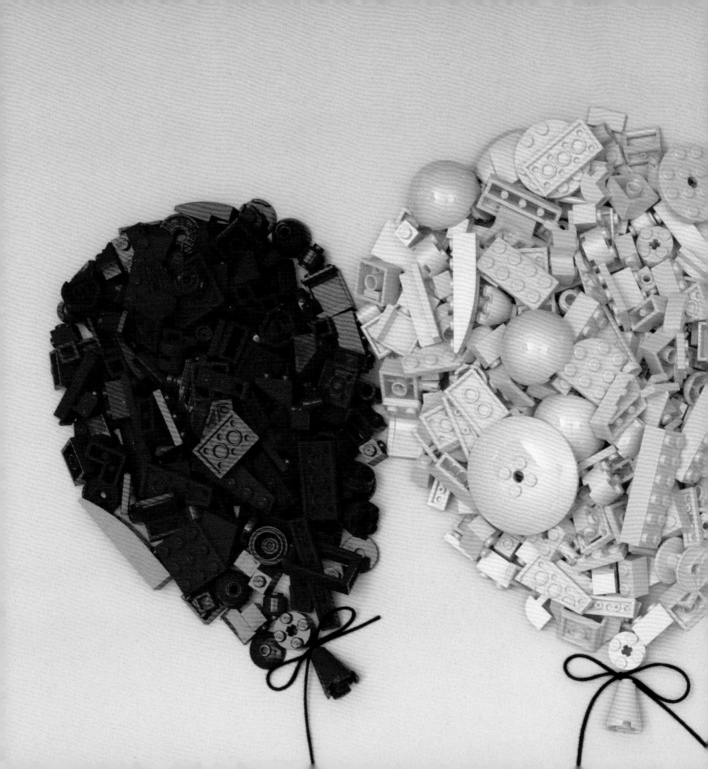

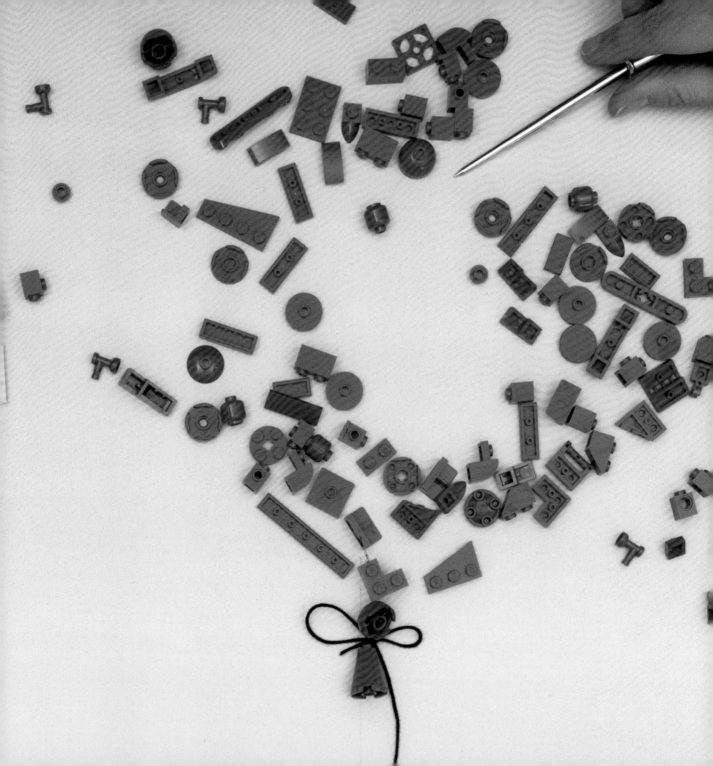

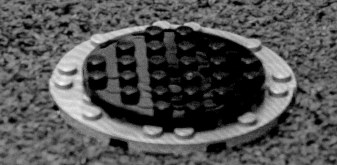

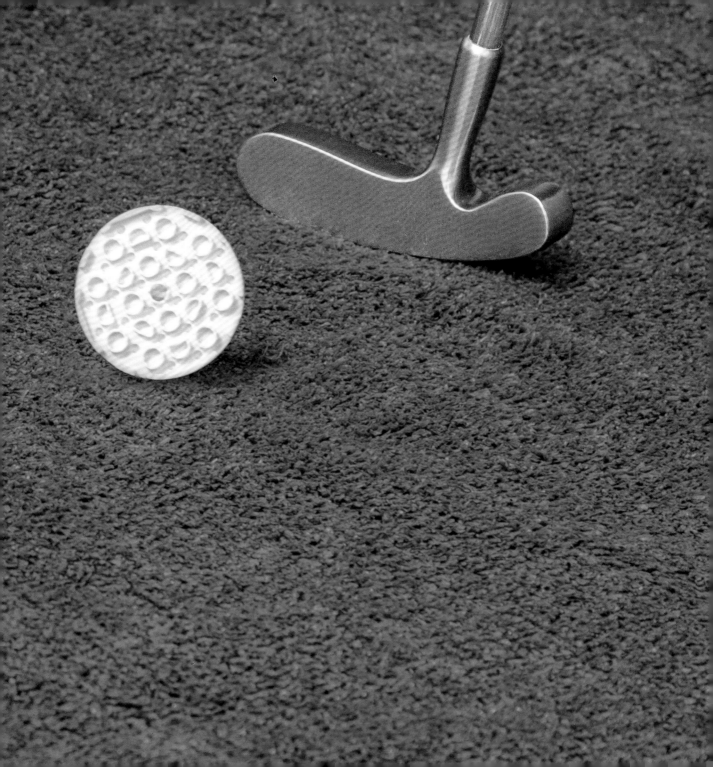

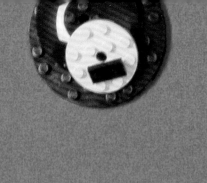

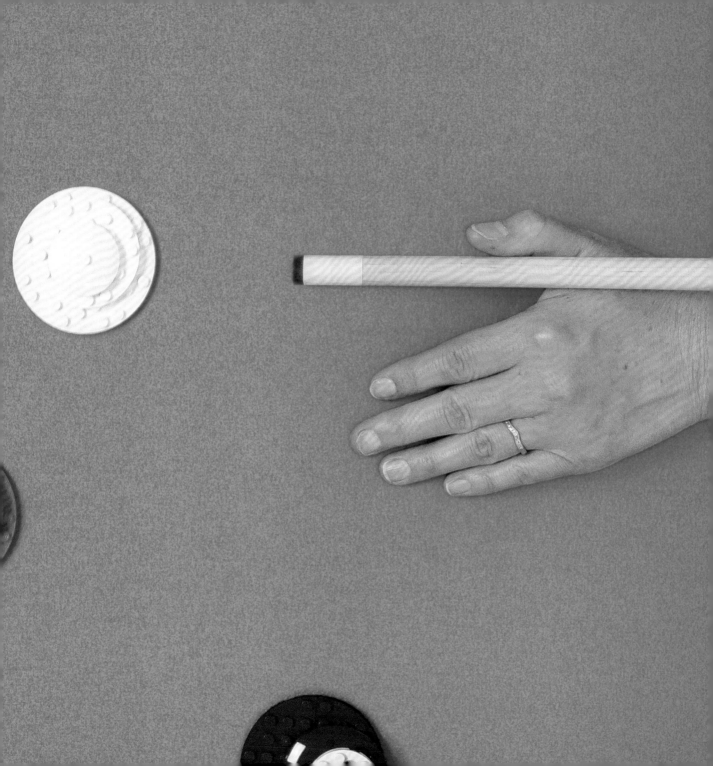

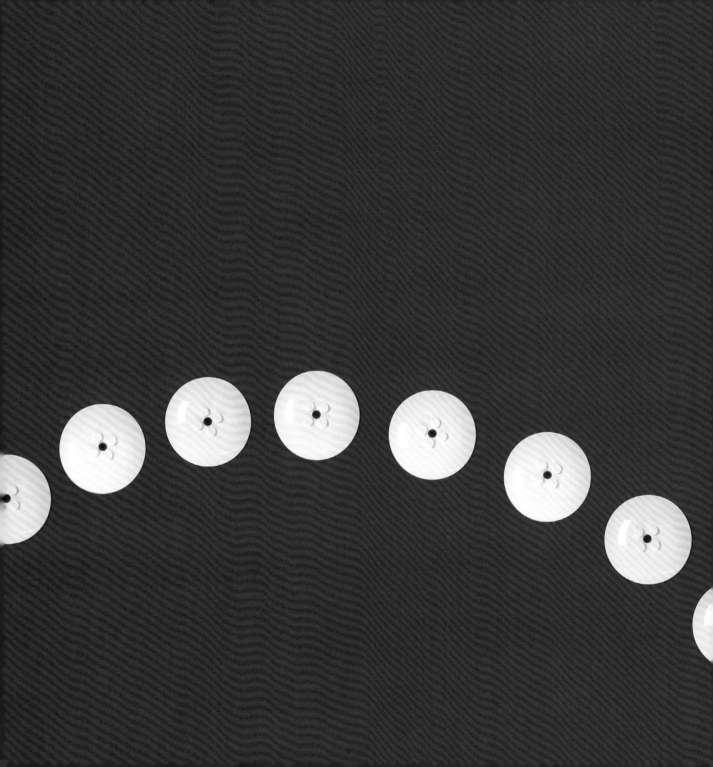

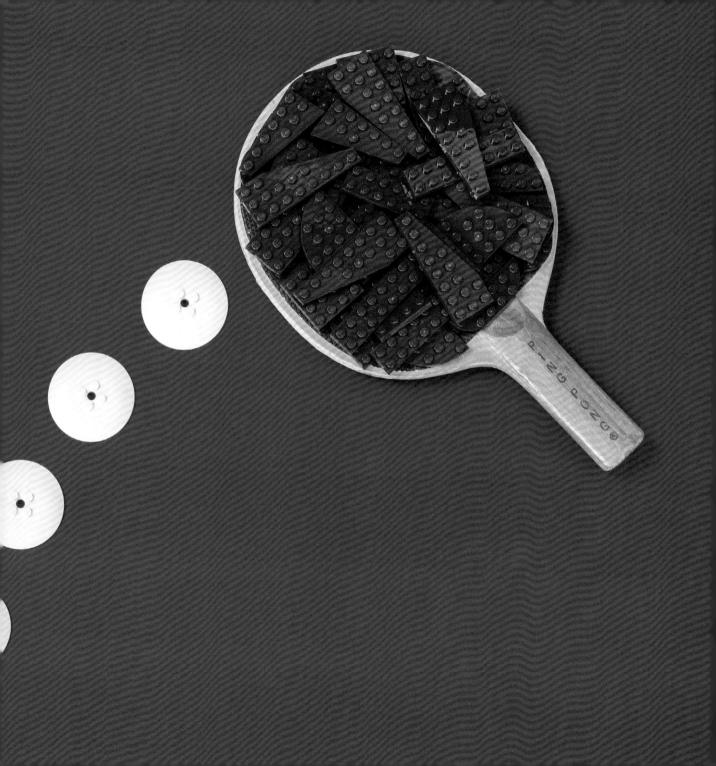

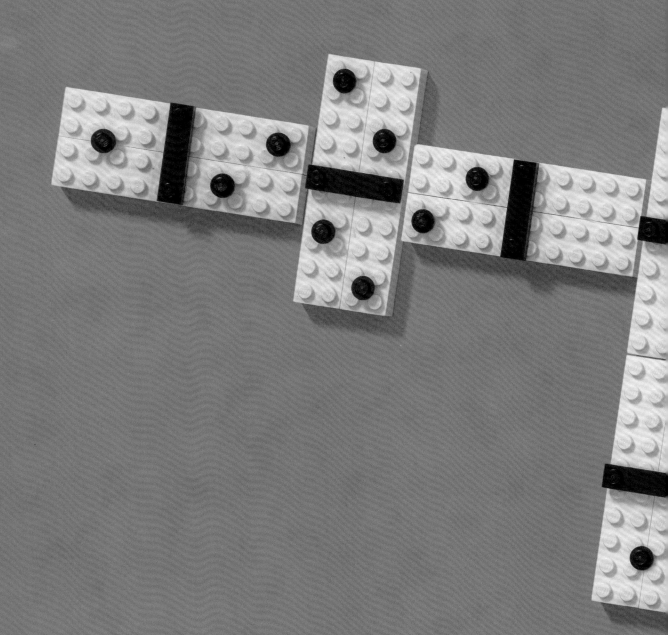

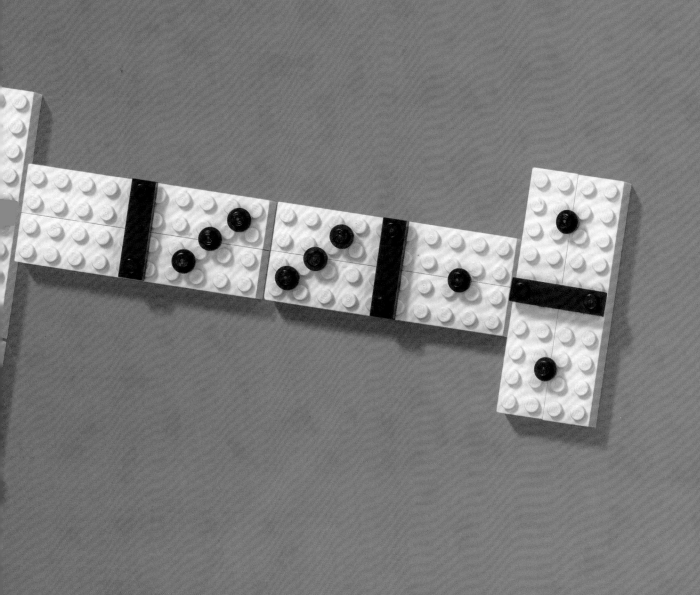

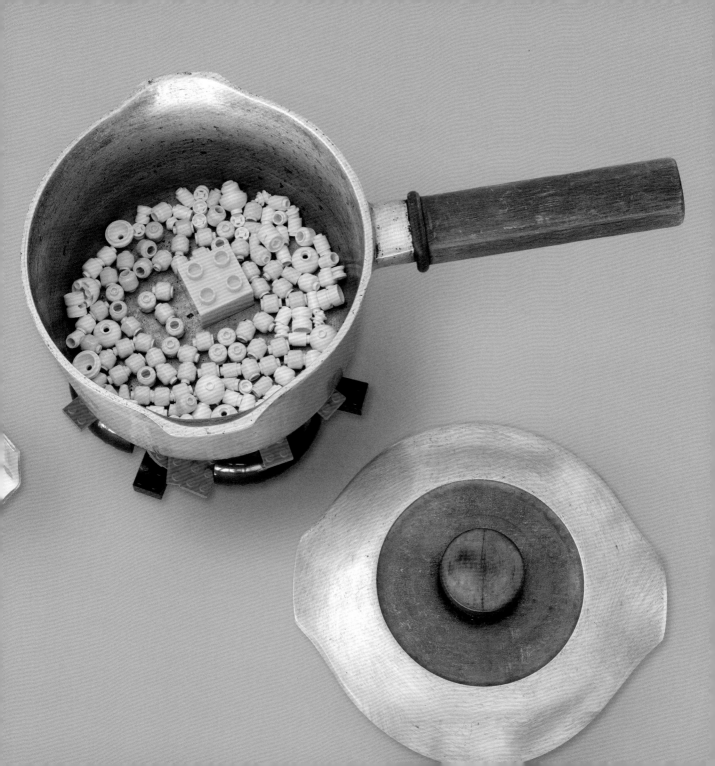

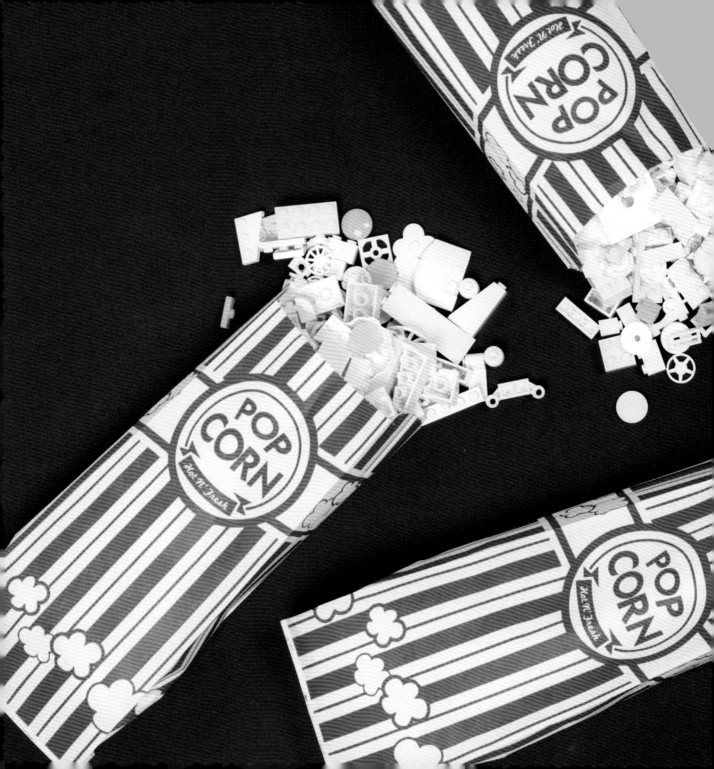

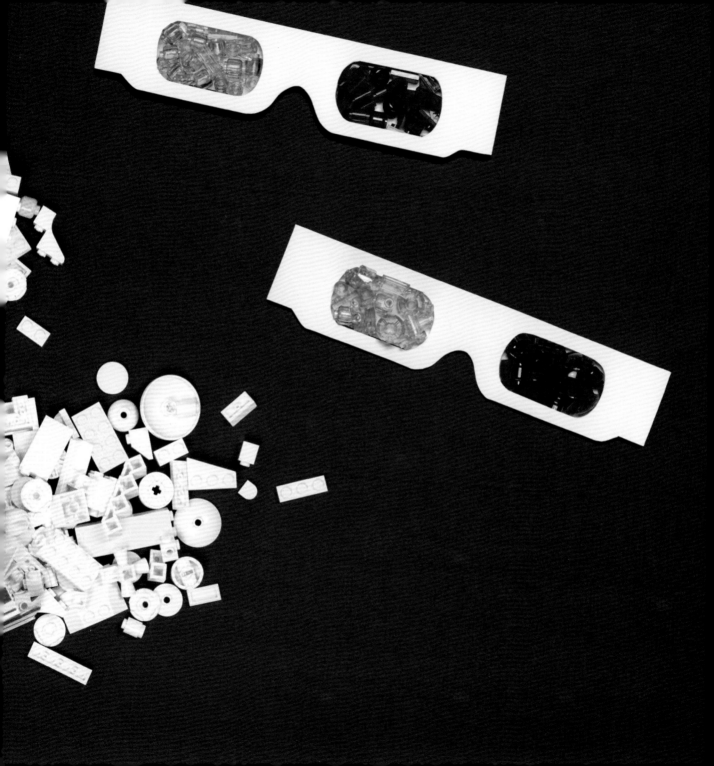

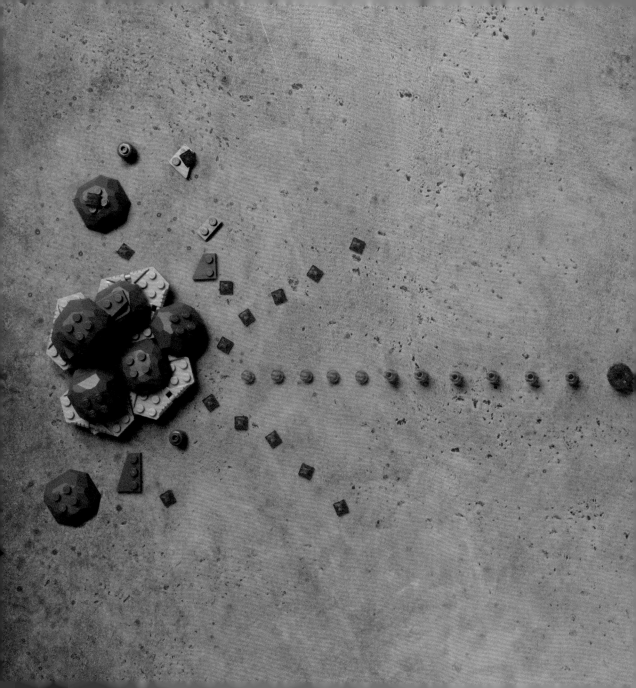

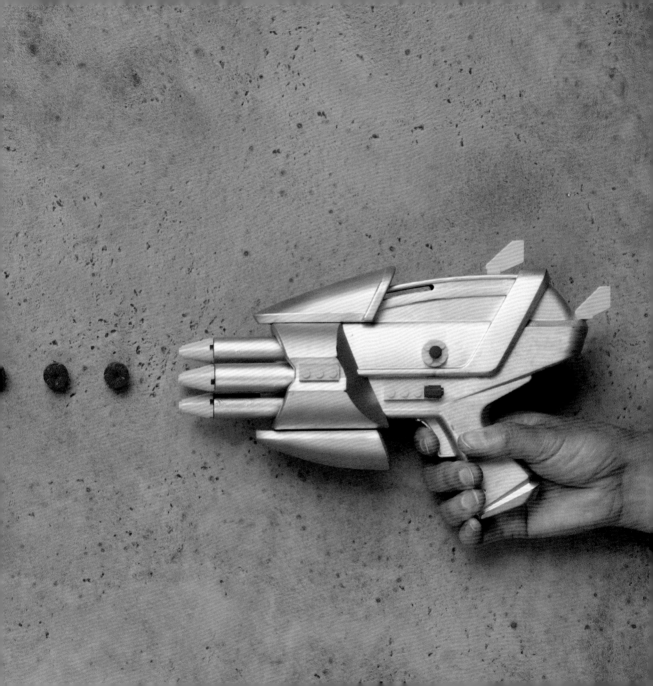

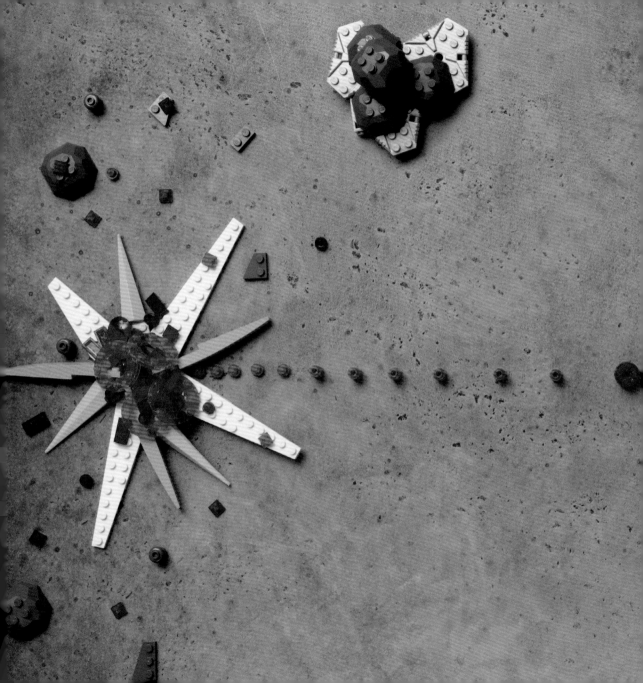

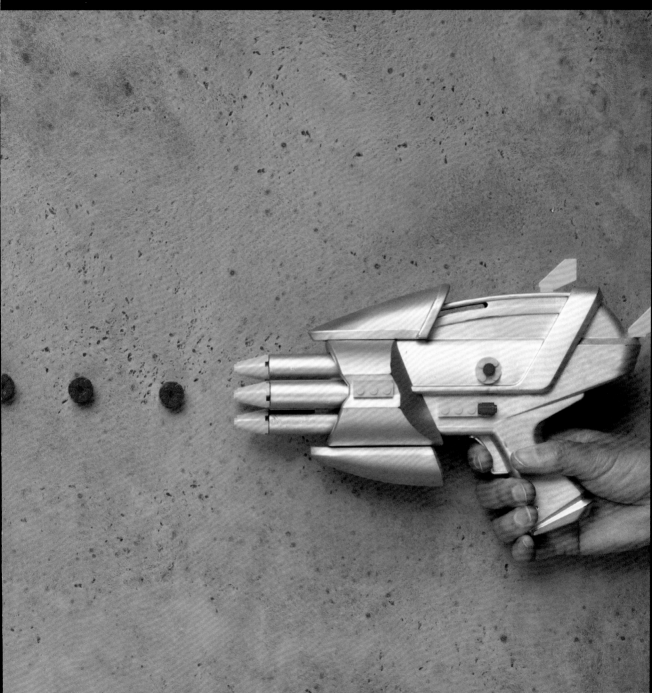

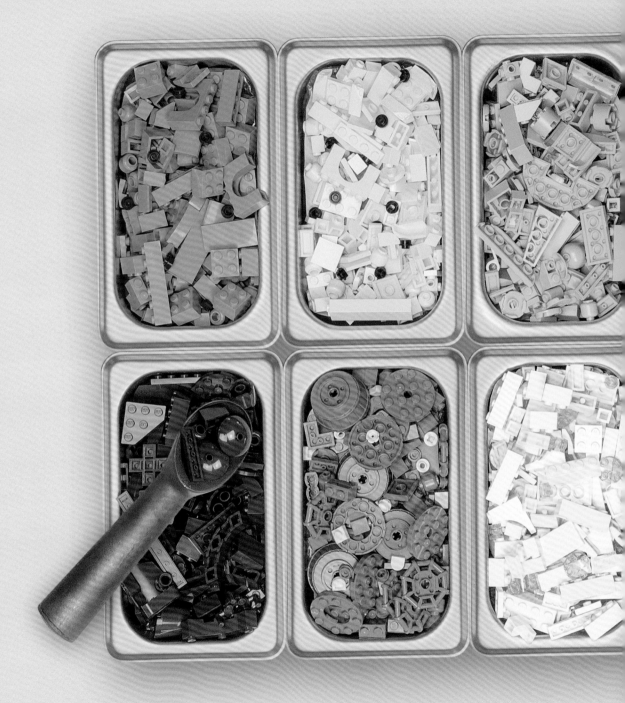

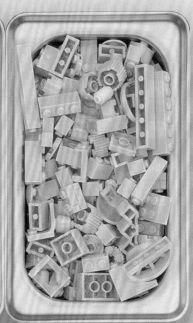
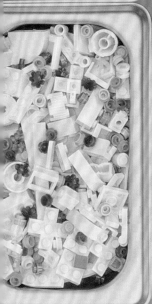
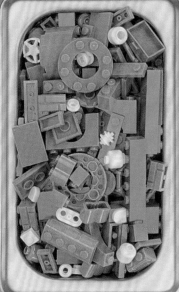
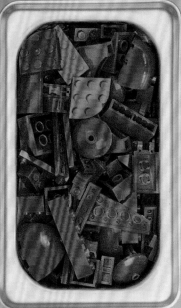

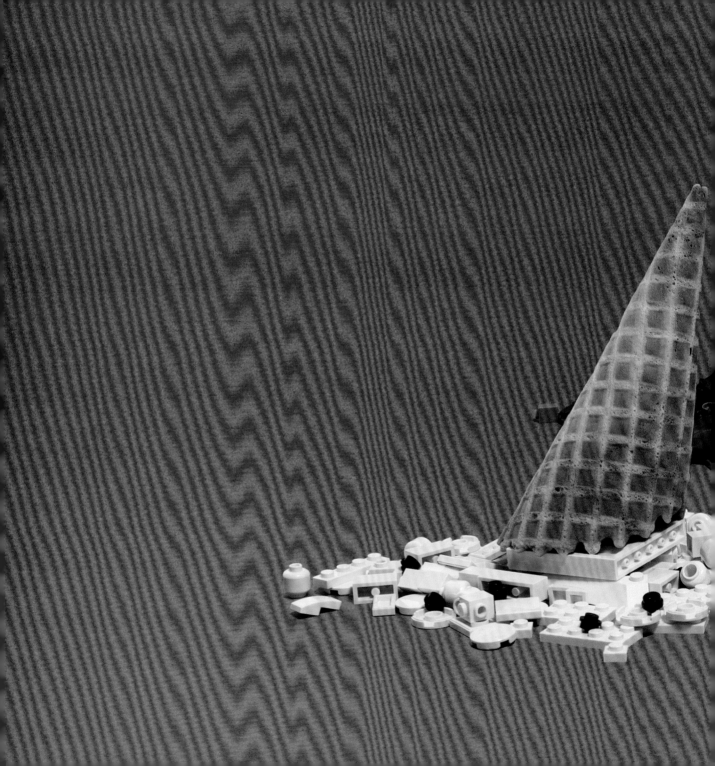

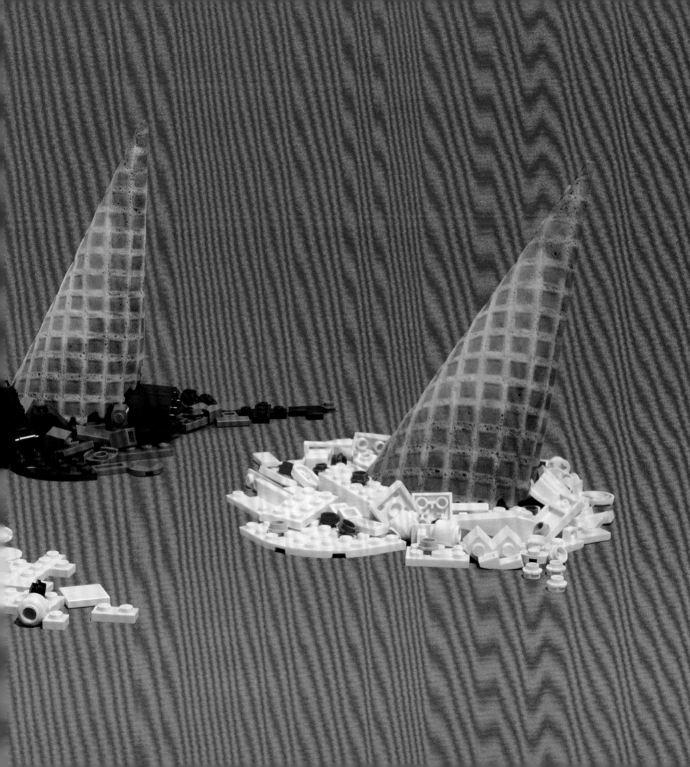

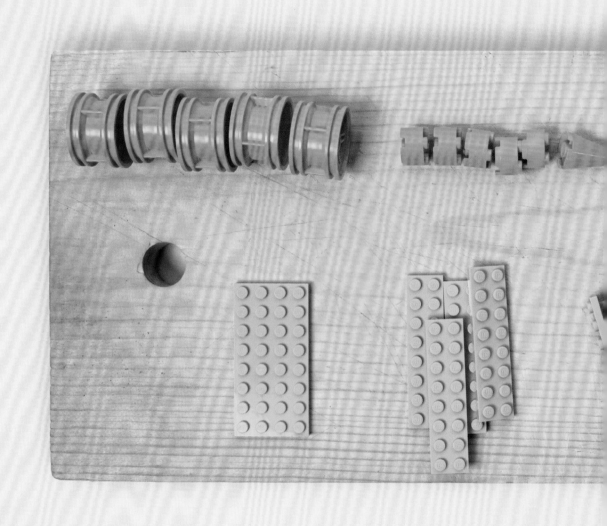

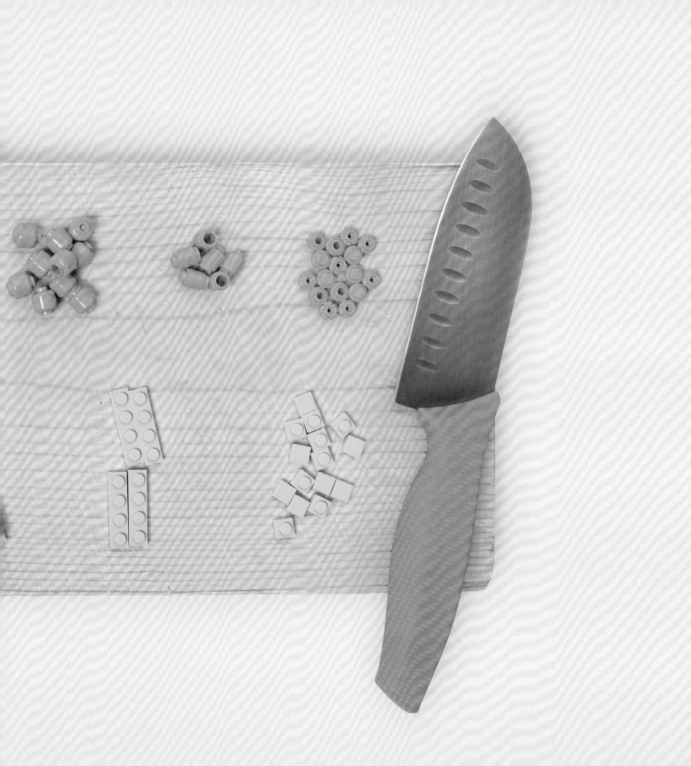

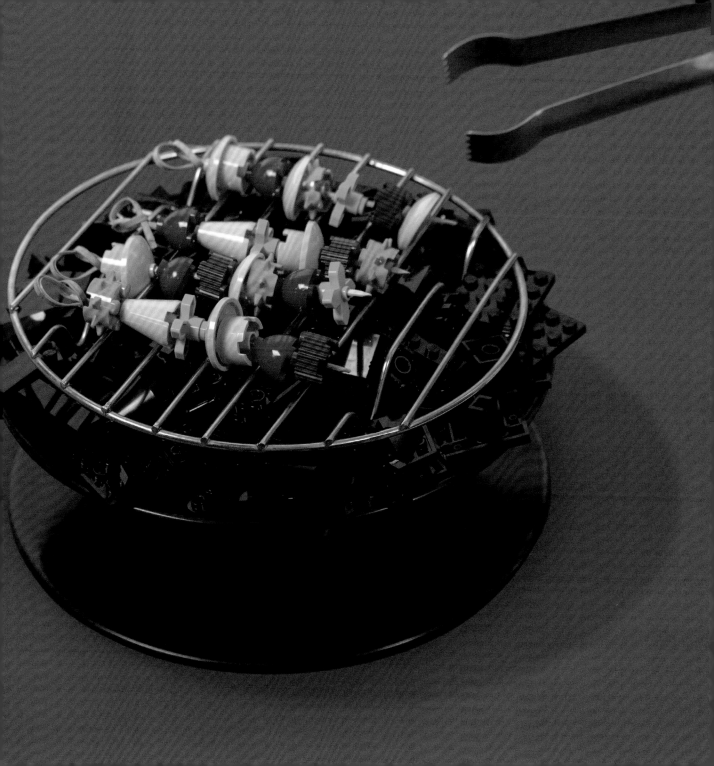

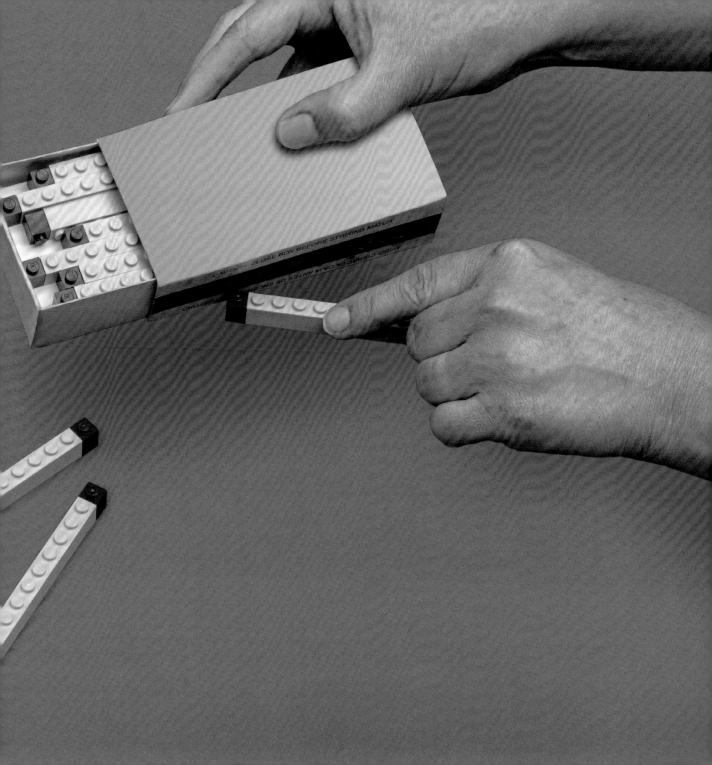

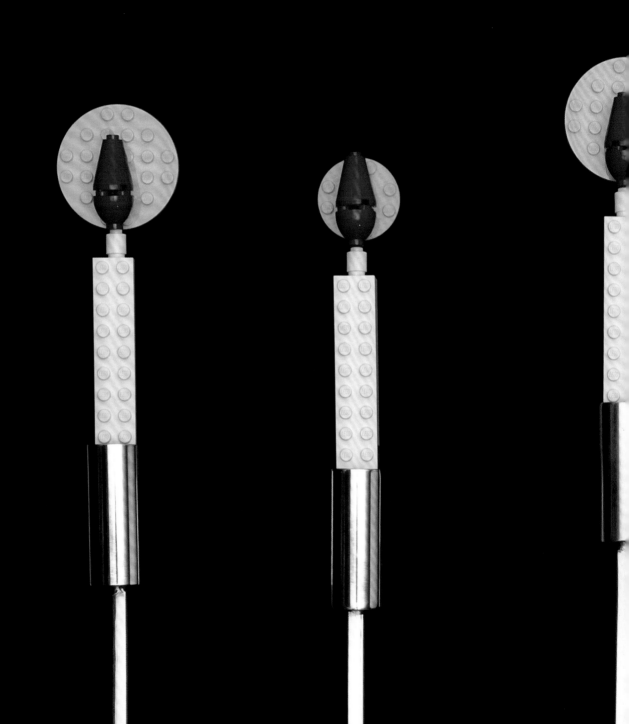

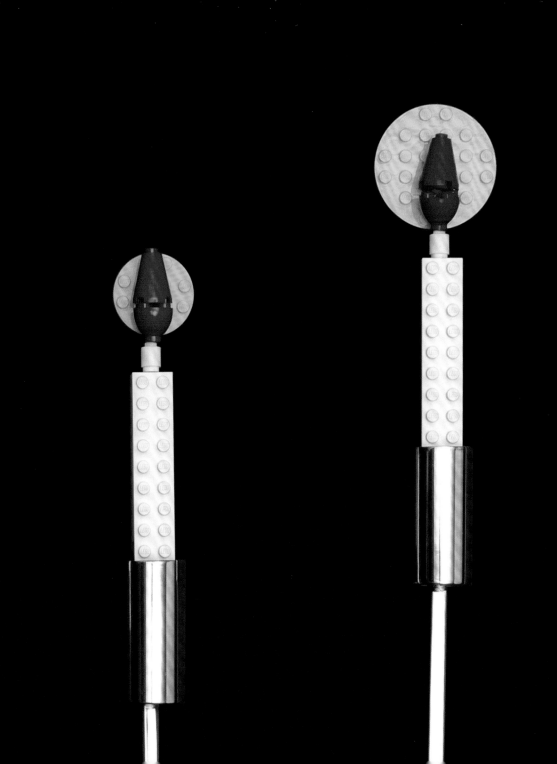

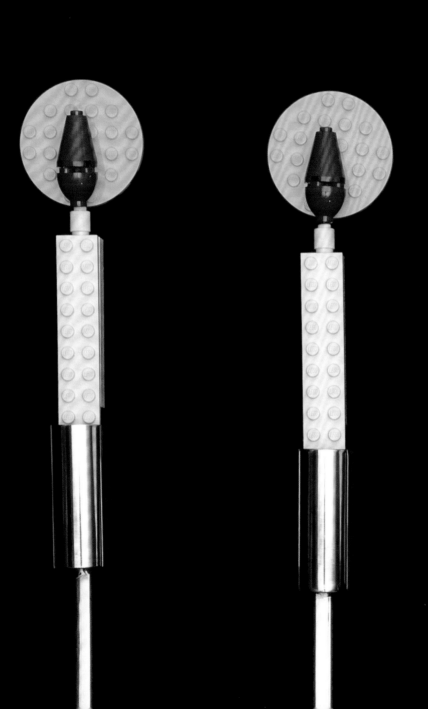

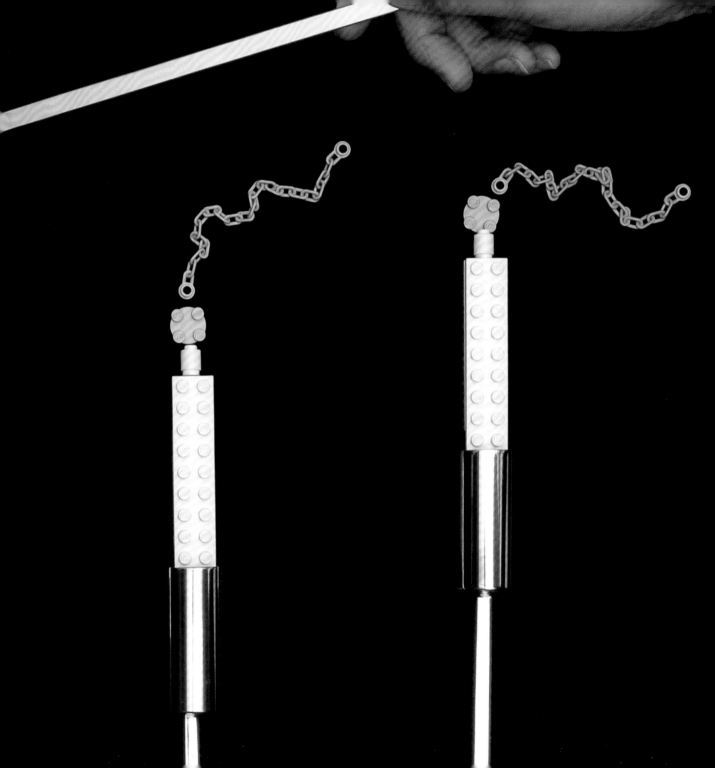

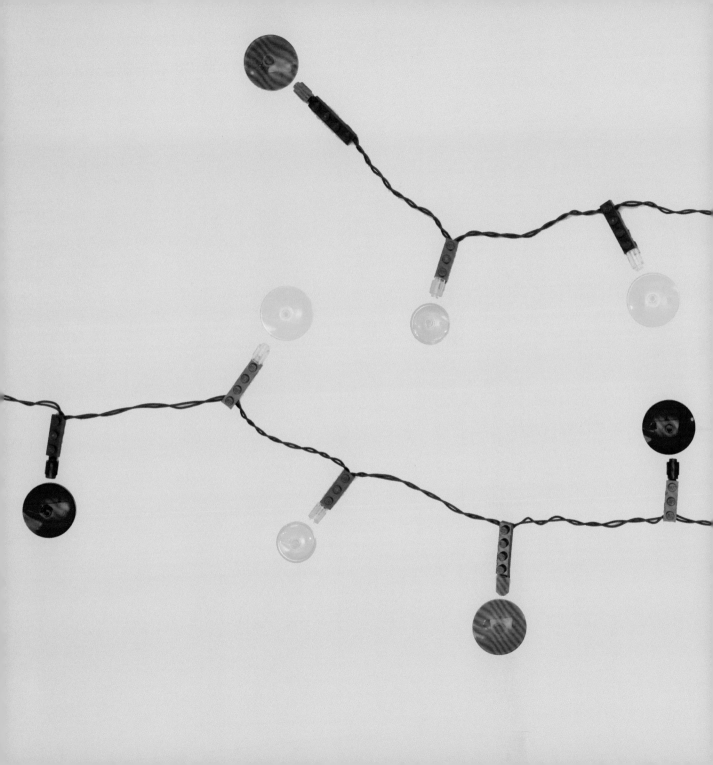

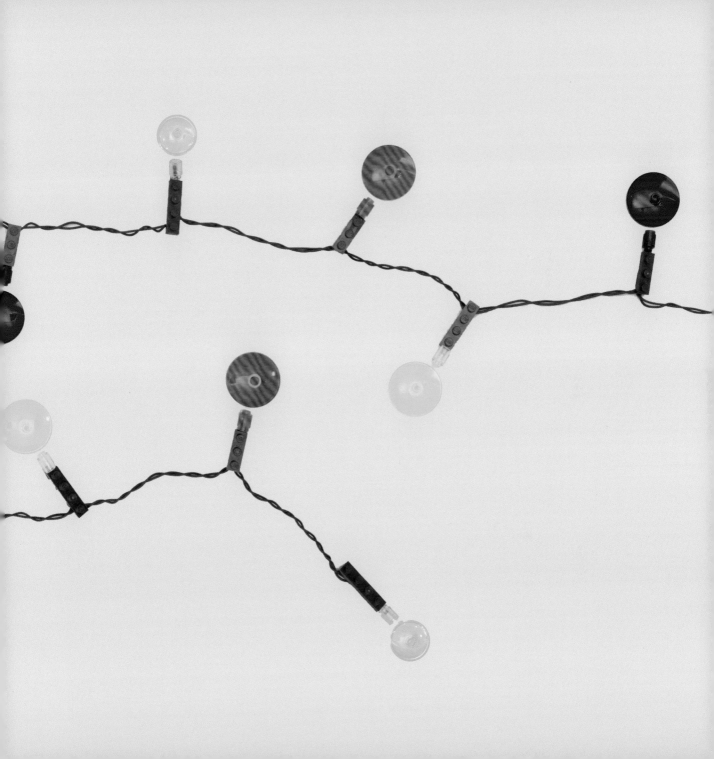

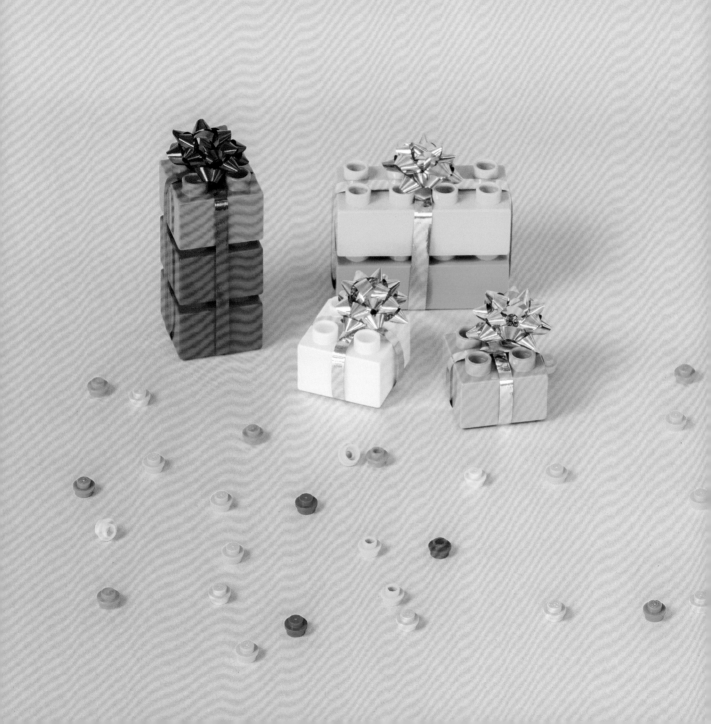

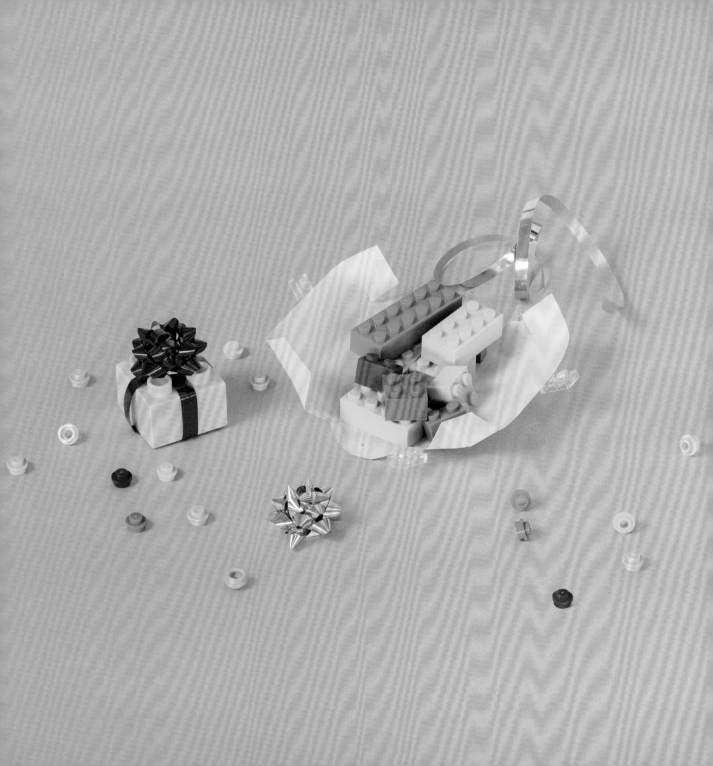

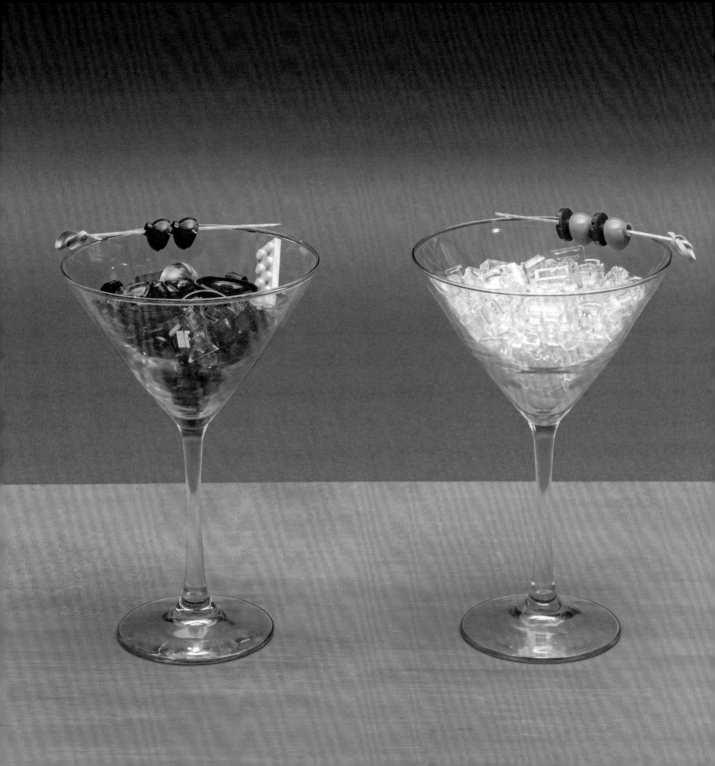

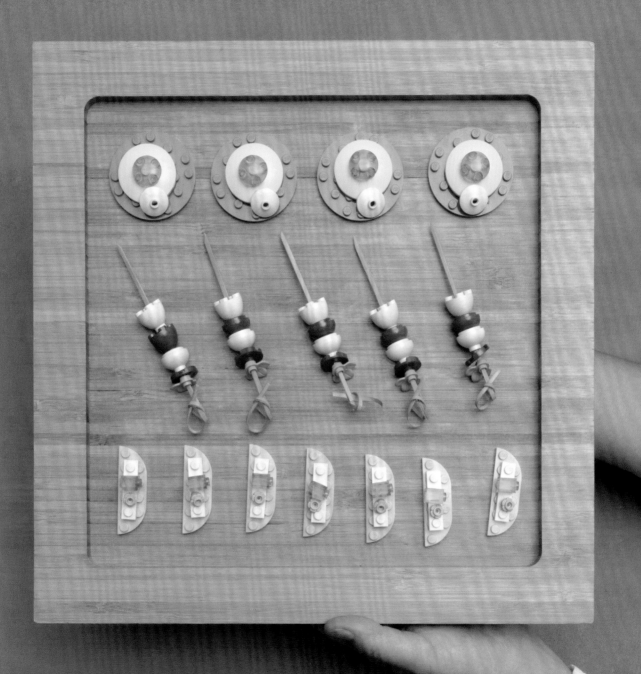

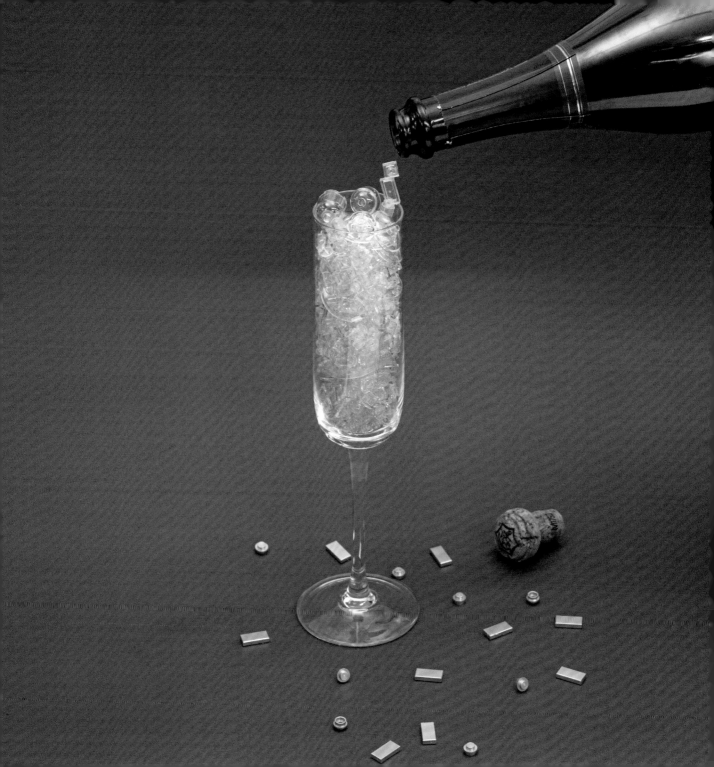

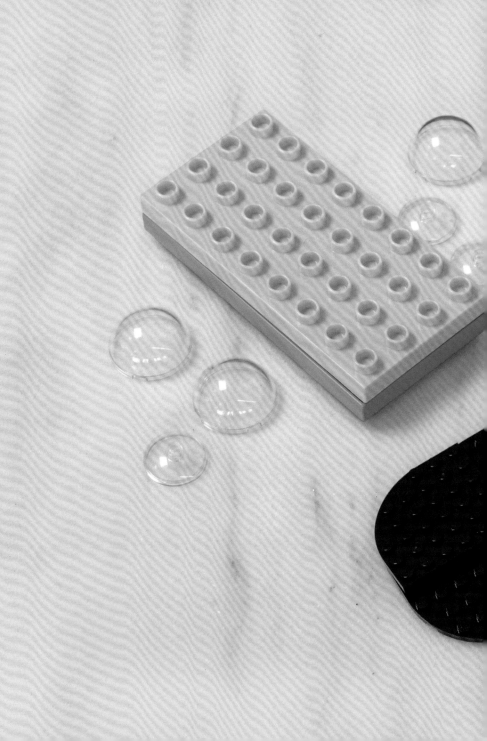

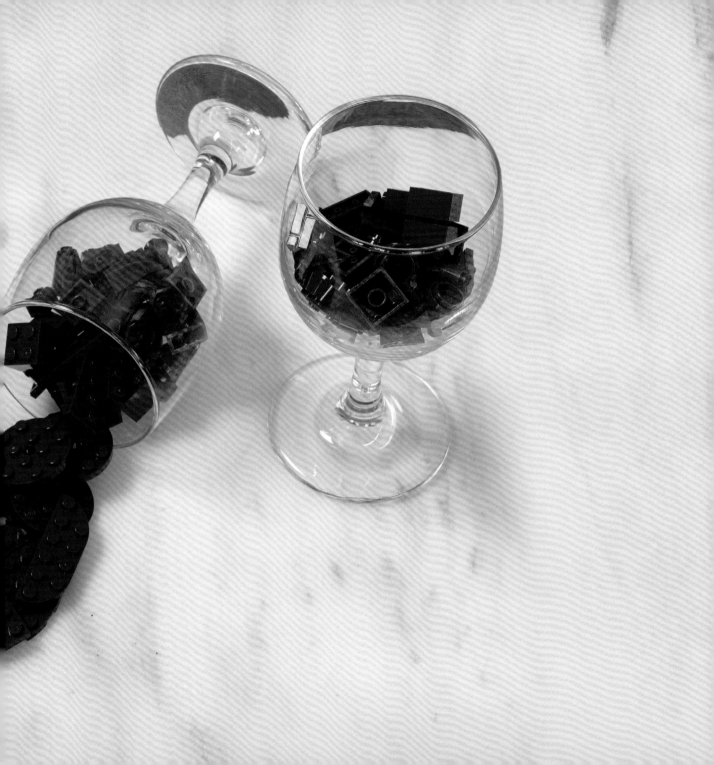

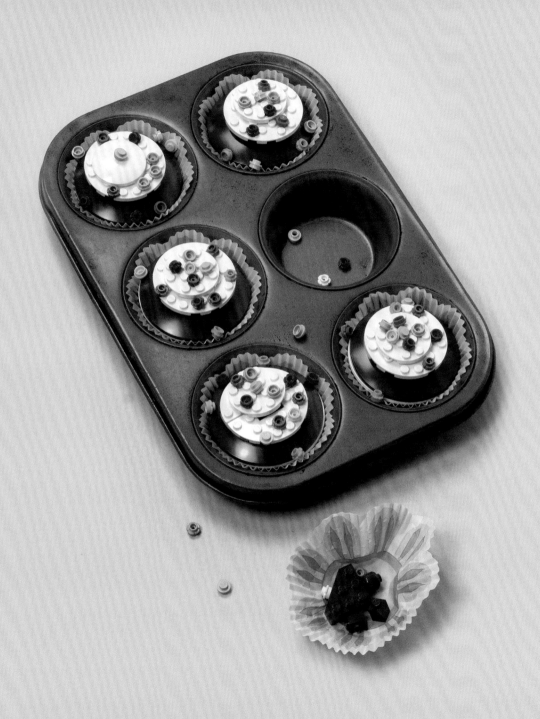

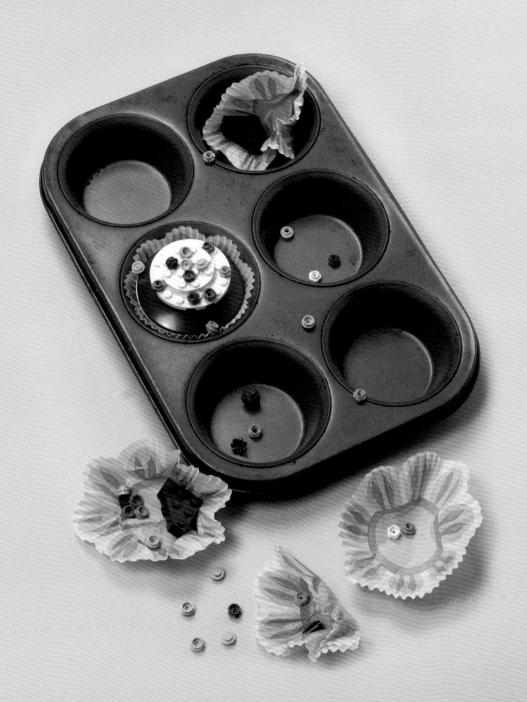

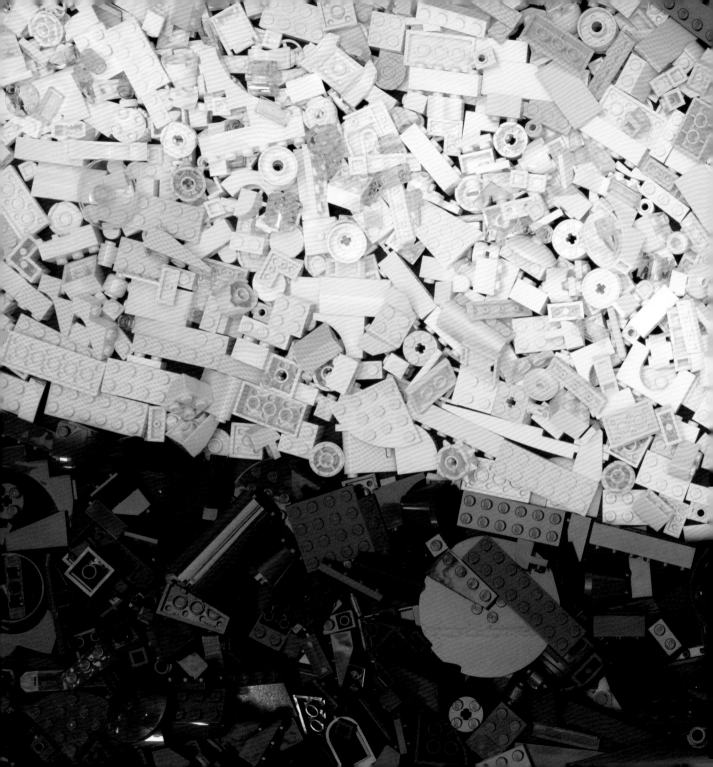

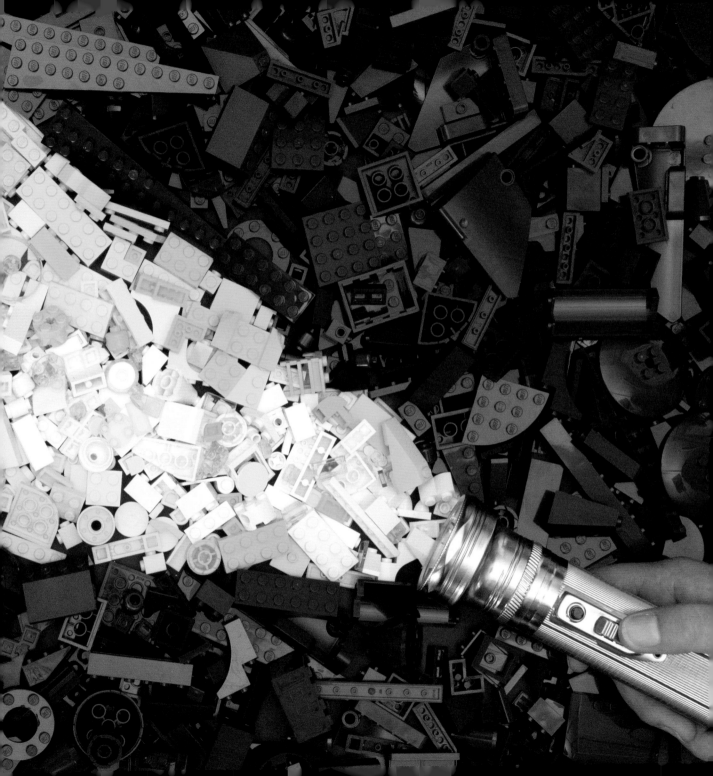

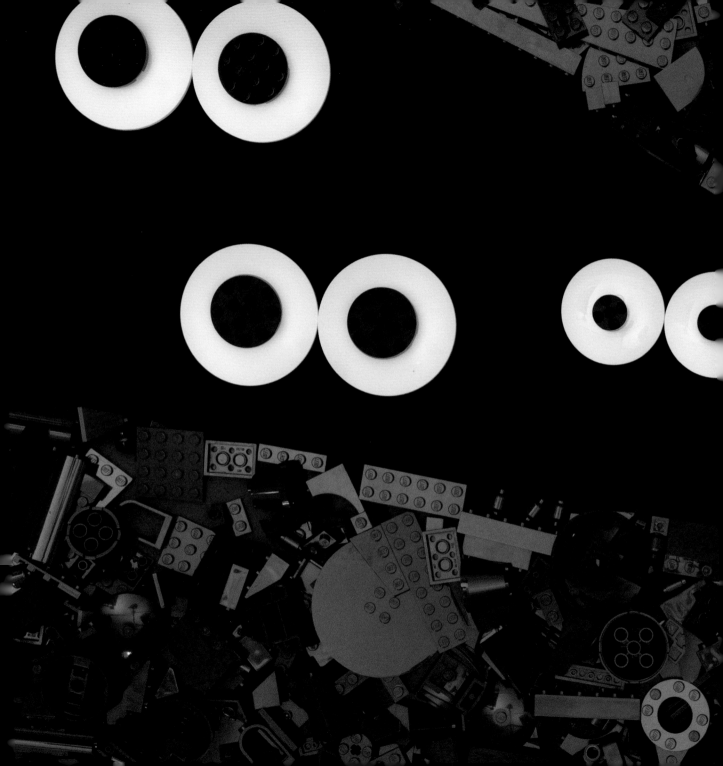

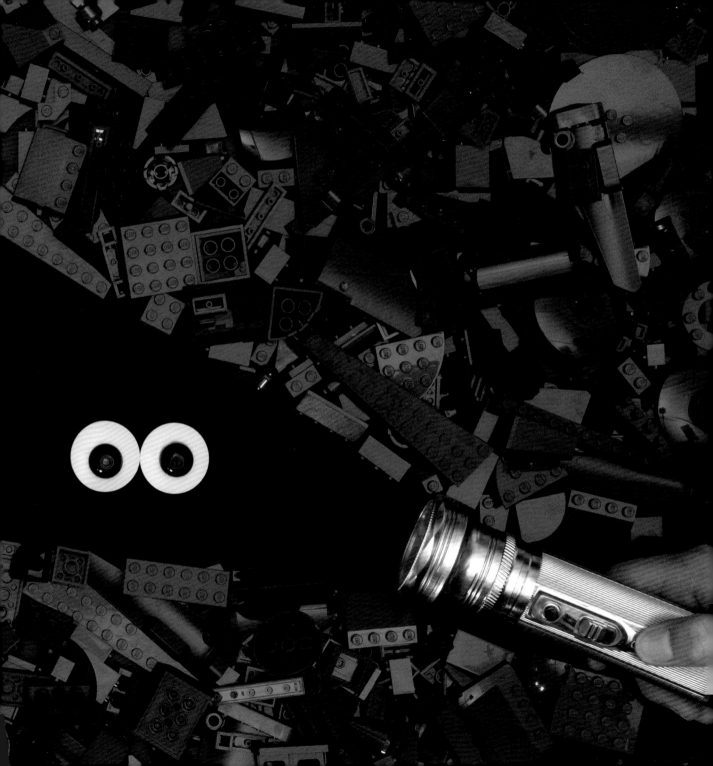

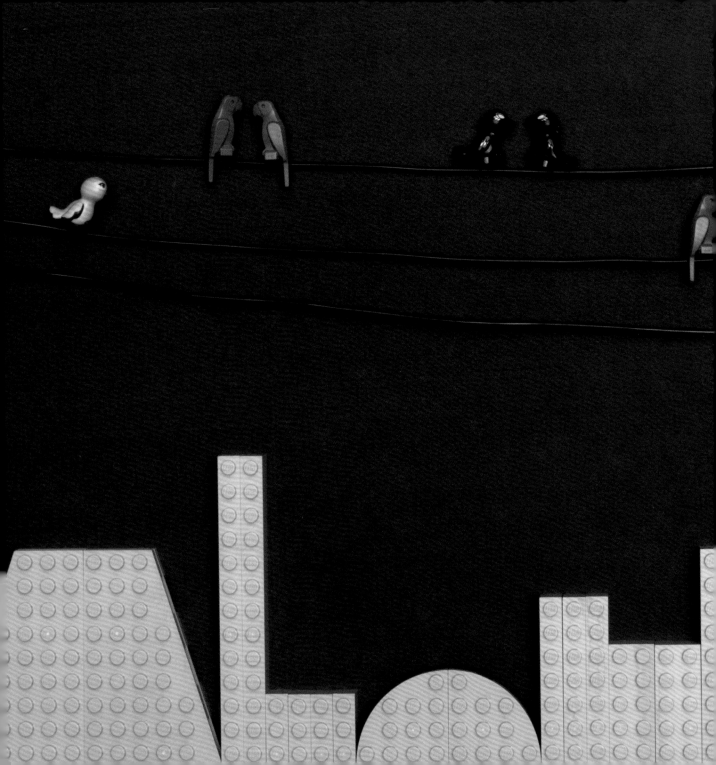

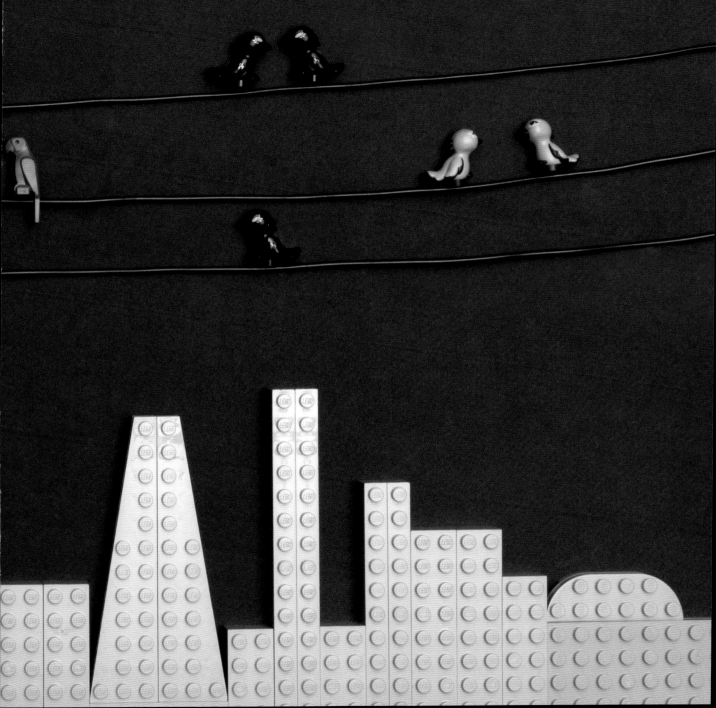

Acknowledgments

The *Still Life with Bricks* project began when several giant boxes arrived at Chronicle Books, each carefully packed with LEGO® bricks. We opened bag after bag, uncovering bricks and elements in every existing color, minifigures of all types, wheels and tires, and all creatures of land and sea. The objective was to build with LEGO bricks in a way that was unique, fresh, and altogether different from the usual building system of snapping bricks together using the knobs and tubes, commonly known as "clutch power."

The opportunity to play all day long was enticing. It fulfilled our need for the nostalgic LEGO play of our childhood and gave us an excuse to be creative with our hands in a way that is often missing from our day-to-day schedules. We thought for days about what this project might be; in the morning when we were getting ready for work, while we were at the office, and again at the end of each day, until we realized that was our direction: transforming the often-mundane routines of everyday life into clever, sculptural pieces of art with LEGO bricks as our medium.

We couldn't have made this book without the boxes of raw materials and enthusiastic encouragement from our friends at The LEGO Group. Our steady-handed photographer, Patrick Rafanan, was essential in helping set up our scenarios and capturing them on camera in a

convincing way. We effusively thank the Chronicle Books team (Sarah Malarkey, Sahara Clement, Alison Petersen, Brittany McInerney, and Michael Morris) for the creative space and measured patience as we convinced them of scenarios constructed in bricks week after week after week. We would like to extend righteous high-fives to our colleagues Aki, Vincent, and Riza for their modeling skills. Over the past months, not a day has gone by without LEGO bricks on our minds (and occasionally underfoot, ouch!), and our lives have become more entertaining and playful because of it.

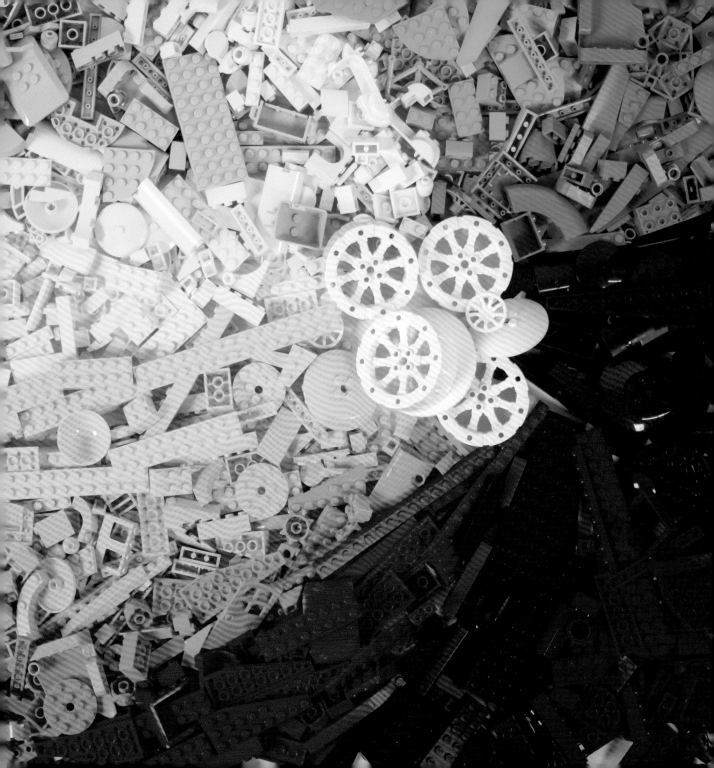

About the Authors

LYDIA ORTIZ is an illustrator and designer living in San Francisco. She chooses projects that focus on bold storytelling and image making to create strong narratives. When she isn't building stories out of LEGO bricks, she draws a lot. In fact, she makes something for herself every single day to keep her creativity fresh and present. Her illustrations have been featured in the *New York Times*, *Washington Post*, *Teen Vogue*, and more.

MICHELLE CLAIR works by day to create and produce gift and stationery products and moonlights as a visual designer. She loves to build things with all sorts of materials, among them wood, fabric, paper, food, and now LEGO bricks. When she's not making things, Michelle likes to hit the hiking trails in the San Francisco Bay Area to admire the visual majesty of the natural world.

Library of Congress Cataloging-in-Publication
Data available.

ISBN: 978-1-4521-7962-9

Manufactured in China.

Design by Michael Morris.
Photographs by Patrick Rafanan.

10 9 8 7 6 5 4 3 2 1

Chronicle Books LLC
680 Second Street
San Francisco, California 94107
www.chroniclebooks.com